HAUNTED PROVIDENCE

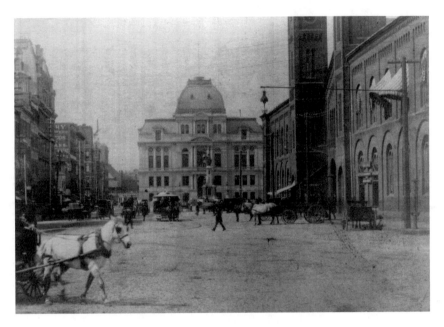

Undated photo of Providence City Hall. The surrounding neighborhood is no less lively today. *Courtesy of Lawrence DePetrillo.*

HAUNTED PROVIDENCE
STRANGE TALES FROM THE SMALLEST STATE

RORY RAVEN

Haunted
America

Published by Haunted America

A division of The History Press

Charleston, SC 29403

www.historypress.net

First published 2008

Second printing 2009

Third printing 2010

Manufactured in the United States

ISBN 978.1.59629.387.8

Library of Congress Cataloging-in-Publication Data

Raven, Rory.

Haunted Providence : strange tales from the smallest state / Rory Raven.

p. cm.

ISBN 978-1-59629-387-8 (alk. paper)

1. Ghosts--Rhode Island. 2. Haunted places--Rhode Island. I. Title.

BF1472.U6R38 2007

133.109745--dc22

2007041972

For my parents.

CONTENTS

ACKNOWLEDGEMENTS

Nobody writes a book on their own. The following people were all onboard with me for this project, and it probably couldn't have been done without any of them or their help. Many thanks to:

My wife, Judith Reilly, who clearly has a lot to put up with;
Barbara Barnes, who was doing tours of Providence long before I;
Michael Bell, for thoughts and advice;
Christine Bevilaqua and Kate Wodehouse, both of the Providence Athenaeum;
Michael Chandley, proprietor of Cellar Stories Bookstore in Providence and a real nice guy;
Rosemary Cullen and Anne Patricks of Brown University;
Larry DePetrillo, for generous access to his massive Rhode Island collection;
Paul Di Filippo and Deborah Newton, friends and inspirations;
The Reverend Dr. W. Flayva, for reasons known only to him;
Jill Jann, for support, encouragement and that laugh of hers;
Sheri La Fazia, mistress of the scanner;
Christopher Martin, the mastermind behind www.quahog.org (the definitive Rhode Island road trip), for invaluable assistance, support, scanning, image wrangling and general swellness;
My sister Maureen, for reading Poe to me by flashlight when I was a child;
My sister Sheila, for sharing my interest in strangeness;
Louis McGowan, for the use of his images;
Ken Pastore, for some great photographs;
George Popkin of the *Providence Journal*, for his 1950s articles on ghosts in Rhode Island;

Acknowledgements

Leon Redbone and Carrie Rodriguez, whose music I listened to constantly while writing this book;

Ian Rowland, who always knew I could do it;

William Schaff, for scanning and critiquing prose;

The lovely Melissa Schwefel at The History Press;

That guy who said that thing that time;

Elizabeth Wayland-Seal and Meri P. Kennedy of the Cranston *HERALD*, for things and stuff;

And to you, for being someone who reads thank-yous.

Introduction

This book records and relates many of the ghost stories and weird tales I have collected about my hometown, Providence, Rhode Island. As one of the nation's oldest cities, it should come as no surprise that so many consider it to also be one of the most haunted.

Although a thoroughgoing skeptic, I have always loved a good ghost story. Any who dismiss ghost stories because "ghosts aren't real" are missing the point completely. Those listening to a ghost story need not believe in the reality of it any more than those watching a play need to believe that the man onstage is really a melancholy Danish prince. Either experience can produce powerful, moving results, or have a message to communicate.

As I collected the stories herein, I became more and more interested in how ghost stories offer links to and overlaps with "real" history, and can serve as a gateway to some who might not otherwise be interested. I can tell you about a mill and its place in the Industrial Revolution and you might not care. If I tell you it is haunted by the ghost of a former night watchman—now you want to hear more.

I consider myself a tour guide and amateur historian (I have no formal training in anything). I am not one of those self-styled "paranormal investigators," who stumble around with night vision cameras and claim to see "orbs" and collect "evidence."

I have never seen a ghost—at least one reason for my skepticism—and really, that's fine by me. If you're dead, please leave me alone.

What I collect are stories—and I hope you enjoy them as stories.

In October 2000 I created the Providence Ghost Walk, a walking tour through the haunted history of Providence, relating many of the ghost stories I have compiled over the years. After each walk, people approach me to relate their tales—the stories they grew up hearing or that were passed

down in their family. I love hearing them. A number of the stories people have told me have ended up either on the Providence Ghost Walk or in this book, or both. I owe many thanks to all of those who stopped to tell me their stories.

Rhode Island has always had a strange contrariety, and has long been home to some unusual characters and practices that flourished here long after they had died out elsewhere. (Where else can you enjoy a May Breakfast?) And this seems to go back to the very beginning.

The State of Rhode Island and Providence Plantations, the smallest state with the longest name, was founded in 1636 by Roger Williams, a Cambridge-educated Puritan theologian. Like other Puritans, he felt the Church of England had not sufficiently separated itself from Roman Catholicism, and he left for the New World hoping to create the City on a Hill and to serve as an example to Old Europe. Arriving in Boston from London in 1631, Williams became the minister of Salem, where he soon made a name for himself for his unusual beliefs, among them being a strict separation of church and state. Sunday worship was often compulsory in the Massachusetts Bay Colony, and Williams averred that "Forced worship stinks in God's nostrils."

While all Christians must obey the Ten Commandments, Williams felt the magistrates of the colony had no right to enforce their observation.

He was also looked upon as an eccentric because he cultivated friendship with the American Indians, learning their language and customs at a time when many dismissed them as heathen savages. While he preached Christianity to them, he made no attempt to forcibly convert them, believing that they must come to God of their own free will.

His concept of "Soul Liberty" applied to both Native Americans and whites—each must be allowed the freedom to follow one's own beliefs without interference from others, least of all the government.

He was brought to trial in 1635 for his radicalism, and the court sentenced him to banishment, ordering:

> *Whereas, Mr. Roger Williams, one of the elders of the Church of Salem, hath broached and divulged divers new and dangerous opinions against the authority of magistrates and has also writ letters of defamation, both of the magistrates and the churches here, and that before any conviction, and yet maintaineth the same without retraction, it is therefore ordered, that the said Mr. Williams shall depart out of this jurisdiction within six weeks now ensuing.*

They planned to send him back to England, but Williams escaped just ahead of those sent to arrest him. He headed south during a long, cold winter, into what is now Rhode Island. There he met a group of Narragansett Indians, who greeted him with the oft-quoted salutation, "What Cheer, Netop?" ("What news, friend?" It should be pointed out that sources seem to disagree as to whether Williams or the Narragansett said it.) They later showed him the way to a freshwater spring, which became the center of his new settlement—Providence—named in recognition of "God's merciful Providence unto me in my distress."

It is significant that Providence was founded around a spring and not a church. This separated it from other colonies in Massachusetts Bay and Connecticut in which the church was not only the founding body, but also the ruling body. Providence soon became, in the words of H.P. Lovecraft, "that universal haven of the odd, the free and the dissenting," and the small town grew larger amid the debates and differences of its inhabitants.

Roger Williams was a man very much driven by his beliefs; a man who, unlike many, truly had the courage of his convictions. No doubt he was a strange and oftentimes difficult man. He was one of the founders of the First Baptist Church in America, but after a mere four months he left the congregation when he could no longer agree with their beliefs.

Thereafter, he avoided attending services at any of the churches that were springing up around him, and only referred to himself as a "seeker" for the rest of his life.

He never gave up thinking, wondering or debating. He once rowed down Narragansett Bay some nine miles in the dead of winter to debate some Quakers who were holding a meeting. He was over eighty years old at the time.

Rhode Island was the scene of the first act of armed resistance against British rule in the colonies, a full eighteen months before the Boston Tea Party. On the night of June 9–10, 1772, a group of Providence citizens attacked HMS *Gaspee*, a British schooner, wounding her captain and burning her to the waterline. The angry colonists included some of the best-known names and faces in the city, but when a reward was offered for the identity of any of the attackers, no one came forward with information. It was widely known who the attackers were—John Brown had supplied them with boats to row out to the *Gaspee*—but no one talked.

There is an interesting side note here: the tavern in which the raiding party gathered was also home to a lodge of Freemasons, who were to hold a meeting that night. I am told that the meeting book for June 9, 1772 reads, "No meeting tonight—more pressing business at hand."

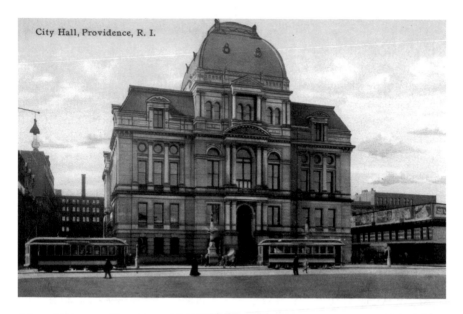

City Hall, Providence, R. I.

A beautiful image of Providence City Hall from an old 1878 postcard. *Courtesy of Louis McGowan.*

Rhode Island was the first colony to break with the British Empire, renouncing its allegiance on May 4, 1776—a full two months before the Continental Congress in Philadelphia.

Having declared its independence, Rhode Island seemed largely content to go it alone, and for a time resisted joining up with the other colonies.

The colony remained an independent republic for a few months, and thrice refused to send delegates to the Constitutional Convention in Philadelphia. In March 1788 it proceeded to vote down the new Constitution by an overwhelming margin. Owing to Roger Williams's legacy, Rhode Island was also slow to ratify it without certain amendments, amendments we now know as the Bill of Rights. One imagines Roger smiling down from whatever heaven he may have entered as he reads over the First Amendment in particular.

The great document was finally passed two years later, thirty-four to thirty-two—no other state in the young nation was so reluctant to accept the new supreme law of the land.

Today, presiding over downtown Providence stands the Rhode Island Statehouse, finished in 1901 and designed by McKim, Mead and White, the famous architectural firm. It is a massive building of white marble, and atop

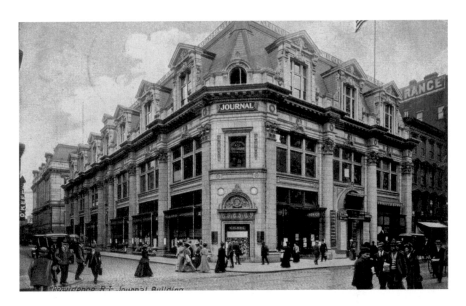

A postcard view of the old *Providence Journal* building. Many strange stories are covered in its pages and filed in its morgue, including several to be found in this book. Thankfully, this building still stands today, despite some rough times that began in the 1950s. *Courtesy of Louis McGowan.*

its great dome stands the figure of the Independent Man holding a spear and the state's symbol, an anchor.

Over the south entrance to the grand building are chiseled the words of John Clarke of Newport, another of the early pillars of the colony and its mission. The words are taken from a speech he made before Parliament. He declared that the people of Rhode Island desired: "To hold forth a lively experiment, that a flourishing civil state may stand and best be maintained with full liberty in religious concernments."

The guiding principle of the colony, quite literally carved in stone.

Join me as we examine where this freethinking legacy brings us over three and a half centuries later.

PART I

HAUNTED PROVIDENCE

AMERICAN INDIAN GHOST STORIES

I am always in search of new stories to add to my rather weird collection. Over the years, I have heard countless stories of shadowy figures at the foot of the bed, mysterious cold spots, footsteps heard in otherwise empty rooms and probably too many anecdotes ending in: "And when I looked back, she was gone."

One area of spooky folklore that intrigues me is that of American Indian ghost stories—legends that must have been told here long before Columbus ever set sail. What little I have been able to unearth so far indicates that, for the most part, Native American tribes didn't have a particularly strong ghost story tradition in the way that the white man did. Native Americans have a very different understanding of spirits and the spirit world. Most tribes have a tradition of feeling very connected to the spirits of their ancestors—meaning both specific family members in particular and ancestors in general. This tradition is often a source of great comfort and even strength. Their spirits are there to help, not to haunt.

And I am well aware that anyone who presumes to speak of "American Indian beliefs" or "Native American culture" can easily land in trouble. There are hundreds of tribes and thousands of stories spread out across the Americas, and a Wampanoag may not have very much in common with a Cherokee or an Aztec.

In the nineteenth century, the golden age of the American magazine, noble savages were in vogue and many authors simply took familiar tales, recast them with "Indian" characters and made another sale. When I came across one story recounting the tale of Chief Stick-In-The-Mud, I began to suspect that this was probably not an authentic Algonquian folktale as the author claimed.

Still, I have discovered one story concerning spruce trees. According to legend, Narragansett Indians hold that each spruce tree marks the spot

where a warrior fell fighting the white man—every spruce tree grows from Narragansett blood and is, in its way, a monument.

One day, a white settler looked out across his land and saw too many spruce trees for his liking. He took up his axe and set about chopping down every spruce tree he saw—clearing his land of any vestige of Native American presence. He didn't get too far in his project, as one of those spruce trees fell on him and killed him.

It might also be noted that American Indians began to tell more ghost stories after they made first contact with Europeans. Most of those stories, unsurprisingly, involve the spirits of the dead returning to warn fellow tribesmen to beware of white men.

Benefit Street at Dusk

B enefit Street, on Providence's East Side, is one of the oldest streets in the city. It was originally laid out in the 1750s and was called Back Street, as it ran along a pathway at the back of the house lots running up the hill from North and South Main Street, then called the Towne Street. In the early 1770s, Back Street was straightened and widened and renamed Benefit Street, as it was said at the time that it would be "a Benefit for All." With its beautifully preserved and restored Colonial and Federal houses, it remains one of the most popular and most photographed neighborhoods in the city. It is a destination for tourists, historians and architects alike. But beneath its picture-postcard perfection, Benefit has a strange history known only to a few.

Until about the time of the Revolution, Providence had no common burying ground. This was the result of having been founded by freethinkers and dissenters, the religious and philosophical refugees mentioned earlier.

While a plot of land had been set aside for a graveyard, most of Providence's early citizens chose instead to bury their dead on their own land—usually out back along that pathway that became Benefit Street. It sounds pretty ghoulish to us, but those were different times and different people.

Eventually, the remains in all those little family graveyards were removed to North Burial Ground, but there is a persistent rumor that some of those bodies were missed, left behind and remain buried along Benefit Street to this day. Perhaps the more tight-fisted residents simply moved the headstones. Something you may want to bear in mind on your next moonlit stroll.

Edgar Allan Poe visited Providence five times to court the widowed poet Sarah Helen Whitman. And although Poe died in Baltimore on January 19, 1849, many say that his visits to Providence continue. On several occasions,

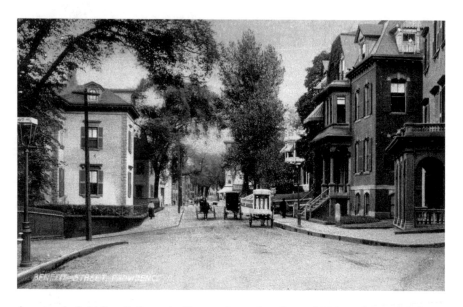

A postcard of old Benefit Street, looking north, much as Poe and various ghosts might have known it. *Courtesy of Louis McGowan.*

a man in black has been seen stalking down the street in the middle of the night, wearing a tall hat and carrying a walking stick, and many feel it is the restless author of "The Raven."

When Poe was in Providence, he sometimes stayed at the Mansion House hotel, a place that had fallen on hard times. When it opened in the eighteenth century, it was known as the Golden Ball Inn and was one of the best inns in the colonies. George Washington stayed there, the Marquis de Lafayette stayed there—both enjoyed a warm bed and the cordial hospitality of the taproom. But over the years it changed hands (and names; for a while it was known as Dagget's Tavern) a few times, and eventually it became a ramshackle place where one stayed when he could afford nothing else.

Toward the end of its days, one of the roomers—a student—was rummaging around the back of his closet and found an old, worn slipper in the back corner. The young man asked up and down the hall if anyone knew whose it was, but nobody did, and nobody even remembered who lived in the room before him. But from the day he discovered the slipper to the day he moved out (a short time later), he was kept awake night after night by the swishing sound of a woman's skirts, as though a ghostly girl was looking for something she had long ago misplaced.

The Mansion House is long gone now. Benefit Street declined over the years and was occasionally described as "a slum," and the once-fashionable

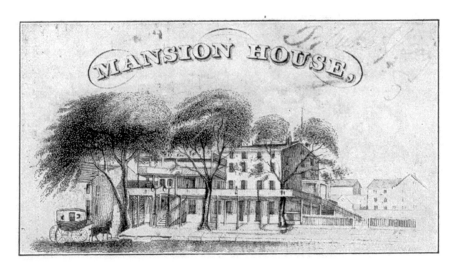

An eighteenth-century advertisement for the Mansion House. *Courtesy of Christopher Martin.*

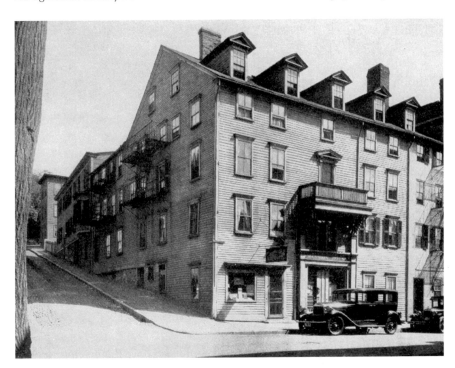

The Mansion House in the early twentieth century. Although largely the same building, Poe and the other guests mentioned wouldn't have recognized it. Sadly, this spot is now a parking lot. *Courtesy of Christopher Martin.*

Downtown Providence in bygone days. *Courtesy of Louis McGowan.*

Mansion House was apparently another victim of the neighborhood's changing fortunes.

A friend from college used to live in an old house just off of Benefit Street where, he told me, he and his housemate would frequently see a figure on the staircase. He said the figure wore a long white shirt and a tricorn hat, and as they thought he looked like a pirate, they called him "the Captain." They saw the Captain several times over the year they rented the house, and would often greet him as they passed on the stairs, but he never responded.

A woman who lived in an old house on Benefit reported hearing piano music at odd times of the day—the same few pieces being played over and over, and not always well. Asking among the neighbors, perhaps hoping to find where the music was coming from, she was told that her house was once a music school some seventy years ago.

An old miser, rumored to possess a great fortune, lived just off of Benefit Street, and each night he patrolled his house with a fireplace poker in one hand and a loaded pistol in the other. He continued to make his rounds after his death, though his house stood empty and no one ever found the rumored fortune. A junk dealer bought the house for five dollars—the neighborhood had begun its slow decline and houses were going cheap. He stripped out the lead sash weights and sold them as scrap for fifteen dollars. The ghost was never heard or seen again.

One misty evening, a young woman was sitting in a little sculpture park on Benefit when she looked up from her sketchbook and saw a horse-drawn carriage roll silently by her. She told me it was in her view for a few seconds before it disappeared completely.

Another resident reports walking down the street late one night when a woman in an eighteenth-century ball gown ran across the sidewalk in front of him. She dashed out into the middle of Benefit Street—where she disappeared. When the man looked back to see from where she had come, he discovered that she had not come out of a door, but straight out of a blank wall.

THE LAMPLIGHTER OF MILL STREET

As you stroll down Benefit Street and admire the houses some evening, pause for a moment to look at the streetlamps. Although electric, the lamps are designed to resemble the old-style gas lamps that once illuminated the street. The gas lamps were installed in 1874, replacing the earlier oil lamps, and seventy-five lamplighters made nightly rounds. One worthy of note was John Quinn, who worked his way through Brown University lighting lamps and later became a lawyer. Described by one source as "a cripple," Quinn gave an account of the lamplighter's lot:

> *We used to carry a ladder, weighting 21 pounds, and a container holding sufficient fluid to light our respective districts…We were paid…3½ cents for lighting oil lamps, and 1½ cents for gas…and had eighty minutes to light the lamps in our section, the time depending on the season of year and the hour the moon came up…Winter or no winter, blizzard or no blizzard, you had to get the lights lit…there were no streets cut in many places, and it was hard to find your way in the dark.*

Another lamplighter once lived on Mill Street, a little lane near Benefit Street. He lived in a modest house with his only child—a daughter—his wife having died some years previously. They were devoted to one another, and each night when the lamplighter returned from making his rounds the daughter would have supper waiting for him—"cold mutton and even colder apple pie," as the story goes.

One especially bitter winter, the girl became gravely ill and her worried father rushed through his nightly route and raced home to be with his ailing child. Every night when he came through the door she seemed thinner and paler.

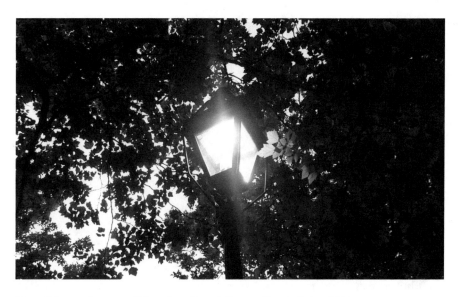

One of the modern streetlights along Benefit Street. *Photo by Robert O'Brien.*

Finally, she lost her struggle and died one cold afternoon, and her poor father was inconsolable.

He laid the girl's body out in a black coffin, which he placed in the front room of the house, under the window that looked out onto Mill Street. He surrounded the coffin with tall black candles, which he kept lit night and day. He never again left the house to make his rounds lighting lamps, he just stayed home tending to his daughter's body, combing her hair, stroking her face and talking to her.

After a few weeks of this, the other neighbors up and down Mill Street grew understandably worried. Calling in the authorities, the poor lamplighter was taken into custody and his daughter was given a decent Christian burial.

The house stood empty for a number of years after the events just described—no one wanted to live there after that.

Still, passersby in the street often claimed to see the young girl's face at the window—sometimes thin and sickly, sometimes healthy and rosy—smiling and waving, occasionally sticking her tongue out and laughing. But the girl was buried long ago, and the house was long since abandoned.

Curiously, Mill Street itself has disappeared. Like so many things, it seems to have vanished in a frenzied shuffle of "urban renewal."

The house and its tenants are gone, and all that remains of them is their story.

THE NIGHTINGALE-BROWN HOUSE

Not all ghost stories are frightening. Some are amusing. This massive house was built in 1791 for Joseph Nightingale, a wealthy merchant active in the triangle trade. His brother-in-law built an identical house next door, which burned to the ground in 1849. Nicholas Brown bought the house from Nightingale's widow in 1814, and his family lived there until 1985. It is now the John Nicholas Brown Center for the Study of American Civilization.

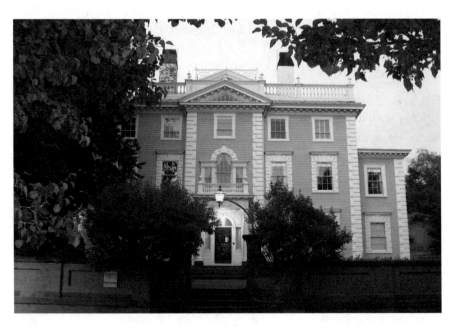

The impressive Nightingale-Brown House on a summer evening. *Photo by Robert O'Brien.*

Some years ago, two janitors were working in the building one night. One of them was new, and the other had worked in the building for a number of years.

The newcomer was cleaning up in one of the big rooms on the first floor, where the eyes in the dour portrait over the fireplace followed him as he swept and straightened. It made him uncomfortable.

Finishing up, he reached for the light switch; illuminating the room were two electric lamps on either side of the portrait. As he did so, he heard a deep voice say, "Don't turn that light out!"

Taking a deep breath, he ran upstairs to find the other janitor.

"Something weird just happened to me downstairs…" he began.

"Yeah, I know," the other man replied. "That portrait talks. Don't listen to it, but leave the lights on."

THE FIERY PHANTOMS OF POWER STREET

In a tall, narrow house lived a family who had lost all their men to the China trade. This was a time when literally thousands of ships sailed out of Providence harbor bound for the Orient, bringing back exotic cargoes of tea, silks and opium. Other ships—such as those owned by the wealthy John Brown, whose family richly endowed the university that now bears the family name—engaged in the slave trade.

When a ship left harbor, it usually embarked with two or three years' worth of supplies packed in the hold, as voyages could easily last that length of time. Some ships never returned to their port of origin, and some others did only many years later with hair-raising tales of their time at sea.

So it was with the family who lived in this house—the men had gone to sea and never returned. But the women never lost hope that one day the front door would be thrown open, father, sons and brothers would return and the family would be reunited.

As a symbol of that hope, the daughter kept a candle burning in an upstairs window, looking out toward the wharves. And one night, sitting up late, hoping to catch a glimpse of a familiar mast in the harbor, she fell asleep. And the wind blew and blew—and knocked the candle over. The candle set fire to the drapes, and the drapes set fire to the rest of the room.

The daughter snapped awake and dashed downstairs, crying to her mother that the house was on fire. The two women clasped hands and fled the house, looking back helplessly as their home burned.

After a few moments, the mother remembered that the family Bible was still in the house. The family Bible, with its record of births, deaths, marriages and other notable events, was passed down reverently from generation to generation—she could not allow it to be lost in the blaze.

The mother raced into the house to recover the Bible.

She didn't come out.

After a few long minutes, the panicked daughter ran into the house to try to find her mother.

She didn't come out.

The neighbors had raised the alarm and called for the fire department, and a few of the crowd wanted to enter the building and look for the two women, but it was too late—the roof collapsed and there was nothing to do but try to extinguish the fire.

When the wreckage had stopped smoldering a day later, friends and neighbors carefully went through the house looking for the remains of the two women. They never found them; mother and daughter had vanished completely, perhaps wholly consumed by the fire.

Years went by, and another house was built on the site of the first. And for years and years afterward, the night watch patrolling the neighborhood reported seeing two women, one young, one old, sitting on the steps of the new house, crying like two souls who had lost everything.

When the night watchman came closer, the women would scream and disappear, leaving nothing behind but the smell of smoke.

THE LIGHTNING SPLITTER HOUSE

The Lightning Splitter house dates from 1780, and was lived in by a sailmaker. Originally a simple rectangular structure, the tall, peaked roof was added in the 1860s, thereby earning the house its name. It was thought that a bolt of lightning would be split in two by the sharp roofline and sent ineffectually to the ground. As far as I know, this theory has never been put to the test.

Speaking with a family who once lived in the house, I discovered that they had some unusual tales to tell. The very night they moved in, the husband walked out the front door to enjoy the summer air and to take a break from a long day of moving boxes, and he saw several figures standing across the street by the Barker Playhouse. The men wore tall hats and buckle shoes. The women wore long full skirts and bonnets. He blinked at them, wondering what he was seeing, and then he remembered that the Barker was performing Arthur Miller's *Crucible*, and these were actors in costume about to go onstage.

Still, the wife told me that she went through three dozen glasses during the time they lived in the house. They simply kept getting broken—that's a glass a month. It was always wineglasses or liquor glasses, never the tumblers out of which the family drank milk or soda, never the coffee cups or juice glasses. Sometimes they would be in another room when they heard a glass break and they would find it shattered to pieces in the middle of the floor.

At one party, a guest named Marie had the wineglass knocked out of her hand by something unseen. As it was always wineglasses, the family thought perhaps it was a Puritan who was occupying their house. And when they told me that, I thought probably not. A good Puritan would stay up in Massachusetts and not come down here to live among the dissenters. Unless of course he found that Massachusetts was not Puritan enough—a truly frightening thought.

The Lightning Splitter House, which looks like it should be haunted. *Photo by Robert O'Brien.*

THE WAD OF CONTINENTALS

In the eighteenth and nineteenth centuries, peddlers traveled up and down the length and breadth of New England, with their packs on their backs and a walking stick in one hand. They made their rounds and visited every few months, bringing not only goods and wares, but news as well. If you wanted to know something, you asked a visiting peddler.

Such a peddler stopped at a small farm on the very edge of Providence, on the busy Fall River Road. He could see that this was not a wealthy family. The roof needed patching and the iron knocker was frozen stiff with rust. When the man of the house answered, the peddler, pointing out that the sun was setting and it looked like rain, asked for a bed for the night. He added that he would gladly help out with any chores in the morning in return.

The peddler was welcomed inside and took a place at the family supper table. In between helpings of the modest fare, the father asked the peddler for any news.

There was uneasy talk and an uncertain future. The Revolution was over and independence from the British had been won, but now what? Nobody knew what was next. The young republic had no president, no constitution—the peddler had even heard that Rhode Island was considering not joining with the other former colonies to form this new country. In the first act of armed resistance in the colonies, Rhode Islanders had burned HMS *Gaspee*—a full eighteen months before the Boston Tea Party. Having done so, most in the newly independent state were happy to go it alone. They saw no need to throw in their lot with the others.

Something was going to have to be done, the peddler said. At least as colonists under the crown there was some kind of order, but now things were more unsettled and more unsettling than ever! Sometimes even the money printed in one part of New England might be worthless in another.

Part I: Haunted Providence

The Market House (1773), the early center of commerce in Providence. Here merchants gathered to sell their wares and trade tall tales. Originally, the arches on the first story were open. *Courtesy of Lawrence DePetrillo.*

He dug into one of the deep pockets of his worn buckskin coat and held up a wad of continentals—paper money that was all paper and no money, he said. He'd have to hold onto it until he got back up north where it was worth something again. Still, he went on, jingling the coins in a fat purse, gold and silver was good everywhere, even if it did make for a heavy load to carry up and down the roads.

When the peddler commented that the winter seemed to have been pretty hard on everyone, the man of the house agreed. Money was tight and he had to work twice as hard to put half as much on his family's table. There was talk about the war debt, and that every family was expected to pay two hundred dollars to help pay it off. Where was he going to find that? And then, he had to pay a new tax just to enter Massachusetts. A tax just to cross an imaginary line! It was almost more than a poor farmer with a small field and a skinny cow could manage.

God willing, spring and summer would be kinder.

When supper was finished and the table cleared, the peddler opened his packs and his pouches and spread out his goods: thread, buttons, brushes, buckles, candlesticks and candle snuffers, American Indian bracelets and even some fine tobacco and pipes.

The family's young son was elated by all this, of course. After a hard winter indoors, with only his parents for company, a visitor—any visitor—

Another view of the Market House, one of the old civic centers. Providence once had an extensive and efficient streetcar system. The old imposing Superior Courthouse, long gone, is to the upper right. *Postcard courtesy of Louis McGowan.*

was exciting, especially one with news of faraway and something to sell. He couldn't understand why his parents didn't share his excitement or why his mother picked up one item after another, only to put it back down after a curt shake of the head from his father.

No purchases were made, and at length the peddler replaced everything in his packs and his pouches. From deep within his coat he withdrew a gold coin that glinted in the candlelight.

"For my bed, and your hospitality tonight," he said. And the coin disappeared into the father's pocket as he led the way up to the attic room with a strange look on his face. When he came back down the family readied for bed as the peddler whistled himself (poorly!) to sleep in the attic room.

The rain outside fell harder and heavier, the wind picked up and the trees bent and twisted.

Late that night, the boy was awakened by a loud bang—from where it came, he couldn't tell. And then there was a scream—a shriek cut short. Terrified, he crept across the floor to his parents' bed. They weren't there—they were gone. The frightened boy felt all around the bed but it was empty. He stood there in the middle of the dark room with no idea what to do. Then a low moan, a moan of pain, sounded through the room and the boy threw himself back into his bed and pulled the covers over his head, praying for sleep.

Morning came, and the boy rose to find his parents sitting silently at the table in the front room, the table where they'd had supper with their visitor the night before.

The peddler was up early and gone, the father said.

The boy was disappointed. A visitor—any visitor—was exciting, and now it was just the three of them again. Still, he was sure that the peddler would return; would stop in the next time he came down the Fall River Road.

Spring stretched into summer, and things got easier and better for the family in the modest little farmhouse. The cow got fat and the father bought more cows and some more land. He even bought some things he had passed over when the peddler offered them for purchase months before—candlesticks and candle snuffers and Indian bracelets. Even the war debt was paid off.

And summer became autumn and autumn became winter and winter became spring again, and the boy felt sure that some rainy night that peddler would return and knock at the door—the door with a new brass knocker—and be invited in to sit down to supper like an old friend.

But the boy never saw that peddler again.

Years and years later, when the boy had grown into a man and death came for his parents after a long life, he found himself in the house alone. He had sold the place to a new neighbor and had resolved to set off and seek his fortune in the widening world.

And the night before he left it rained, just like it had that night so long ago, and he walked through the old house for the last time, checking in every corner, in every cabinet, part of him making sure that nothing had been left behind and part of him saying a final goodbye to the house where he had been born.

And he went upstairs to the attic room, where the peddler had slept next to the chimney. The room was empty and still and for some reason he wasn't quite at ease standing there.

And there was a bang—a bang he had heard once before when he was a boy. And one of the big fieldstones that made up the chimney crashed to the floor. And the house shook.

He looked into the hole, a big black hole, and he could just make out something that shouldn't be there. He reached into the hole and pulled out a worn old buckskin coat and a couple of big empty packs and pouches. Peering into the black hole, he saw a gleaming skull looking back at him with empty eyes and a horrible grin.

And he heard it again—for the second time in his life he heard that scream—that shriek cut short. Terrified, he stood in the middle of the room with no idea what to do when a cold breeze that was more than a breeze

rushed past him. And the door at the foot of the stairs banged open. He realized that only now did he feel that he was alone in the room.

The boy who had grown into a man picked up his bags, swung up onto his horse and dug in his heels, and never came back to Rhode Island for as long as he lived.

This foregoing story, clearly drawing on several established folklore motifs, bears a strong resemblance to another story, which did not take place in Rhode Island but would have repercussions felt here.

In March 1848 two little girls in Hydesville, New York, a tiny upstate hamlet, claimed to be in touch with spirits of the dead. Their names were Margaret and Kate Fox. The spirits communicated by producing mysterious raps from nowhere. The girls and their spirits became a local sensation, and they charged twenty-five cents for a séance.

In messages rapped out from beyond the grave, the spirit haunting the Fox family cottage claimed to be of a murdered peddler, who gave his name as Charles B. Rosma and alleged to have been killed for his money and buried in the cellar.

Word spread quickly, and soon Horace Greeley ("Go West, young man!") heard about them and brought them to New York City. The girls were an immediate hit with New York society, and a quasi-religious movement called spiritualism swept the land. The list of those attending séances reads like a "Who's Who" of nineteenth-century America: Julia Ward Howe, Harriet Beecher Stowe, James Fennimore Cooper, Abraham Lincoln (who allegedly rode atop a piano being pushed about by unseen spirits). Commodore Cornelius Vanderbilt, the millionaire, attended séances to get stock tips from the beyond.

By 1850, there were some two hundred spiritualist "circles" in Ohio alone, and the movement was making its way west to San Francisco.

Within four years, séances crossed the Atlantic to London where, rumor had it, Queen Victoria herself was trying to contact the spirits. Skeptical Charles Dickens penetratingly said, "I have not the least belief in the Awful Unseen being available for evening parties at so much per night."

Spiritualism was a grab bag of ideas—serious questions, philosophical and scientific inquiry and weird party games. It is a fascinating and largely forgotten chapter of American history.

It also became big business for the mediums—the ones who were actually doing the supposed work of contacting the dead for paying customers.

Spiritualism proved popular in Rhode Island, a state founded by freethinkers and seekers, many of whose descendents still yearned for something they could not find in "conventional" religions.

Part I: Haunted Providence

In my collection is an undated nineteenth-century broadside advertising a performance by a Dr. T. Sylvanus of Killingly, Connecticut. The good doctor was in Providence to give a series of lectures on spiritualism at the Howard Hall, and as a publicity stunt he had borrowed instruments from a brass band, and according to the broadside, these instruments were to be played upon by spirit fingers in the open air of the railroad yards, which then occupied much of downtown Providence. The demonstration was to take place at noon, when the instruments were to be levitated in the air some twenty feet.

I have been unable to find any account of what may (or may not) have happened, and all attempts to trace Dr. T. Sylvanus have, alas, failed.

In 1888, forty years after it all began, Margaret Fox, now a destitute middle-aged alcoholic, confessed that the whole thing had started as a prank she and her sister were playing on their mother. The famous spirit raps were produced by the girls cracking the joints of their toes. And as the sensation spread, the two little girls were too scared to stop, so the movement grew and grew out of their control.

She had hoped that she could put an end to a prank that had gotten out of hand, but she was sadly mistaken. Despite denouncing spiritualism as a fraud of the worst description, few believed her, and many continued to attend séances. Eventually, the hopeless and bankrupt Margaret began holding séances once again, producing the mysterious raps that had convinced so many of the reality of spirit contact.

At some point in their prank-playing, someone must have asked Katie and Maggie who or what was making the raps. Put on the spot, lacking an explanation, they may have latched onto a story they had heard somewhere or other—there are many versions of the "murdered peddler buried in the cellar" story. They may have heard it quite a few times.

I have always imagined the two little girls, faces lit by candles, standing before a roomful of curious adults expecting an answer, exchanging nervous glances and saying the first thing that came to mind. How many tales spun by children today bear more than a passing resemblance to movies and television shows? It was certainly no different a century and a half ago in Hydesville.

There was an attempt to dig up the Fox family's cellar to find the body, but sources differ as to what was found. Believers in spiritualism insist that his bones and an old peddler's box were found. Skeptics maintain that nothing was found.

THE SLAVE TUNNELS OF
COLLEGE HILL

Despite its guiding principles of "Soul Liberty," Rhode Island did play a part in the infamous triangle trade of rum, slaves and molasses, and that unfortunate chapter of history has given rise to one of Providence's most enduring urban legends.

In Rhode Island, "sea captain" is often used as a euphemism for "slave trader" and many of the state's prominent families, such as the Browns and the DeWolfes, earned at least part of their fortune trafficking in slaves. Newport was a major port, where molasses and sugar could be made into rum at one of the many distilleries in town. The rum was then brought to Africa to trade for slaves, who would in turn be traded for more molasses and sugar in the West Indies, starting the cycle again. There was an active slave market in Providence, as well, which is the basis for this particular legend.

Rhode Island abolished the slave trade in 1787. Even John Brown gave it up because he felt it to be "Immoral and unprofitable" (although, knowing him, probably not in that order). But the legend goes that many, unwilling to give up their livelihood, continued trading in secret. Up to this point, the legend is undoubtedly true—John Brown himself, for example, returned to the slave trade after a few years' absence. Apparently, it was not as unprofitable as he originally claimed.

But the extreme measures to which the slavers resorted are the basis for the legend, still recounted in Providence today.

To keep their involvement secret, merchants supposedly dug tunnels leading from the waterfront, where ships would arrive with a group of slaves, to various houses on the city's East Side. The slaves would be rushed up through the tunnels to wealthy families who were either customers or merchants themselves.

Many years later, so the story goes, these tunnels were put to another use—helping freed slaves escape to Canada on the Underground Railroad.

Apparently, advocates of this part of the story are taking the idea of an underground railroad a bit too literally.

So, while Rhode Island does have slave trading in its past, and you may hear stories about these tunnels honeycombing College Hill, you won't find any actual slave tunnels. No one ever has; because they aren't there. They are an urban legend.

I have on many occasions been told the same story—"I used to know someone who used to know someone who lived in a house with a slave tunnel in the cellar."

Names and locations are not forthcoming, of course.

Folklorists will recognize this as the classic "Friend of a Friend" (FOAF) story, and everybody has heard at least one—alligators in the sewers, Pop Rocks and soda, et cetera. No one ever produces a first-hand account of the strange events described. They always have happened to a friend of a friend, someone met only once long ago or some similarly distant or unavailable informant. (Readers interested in the subject are referred to Jan Harold Brunvand's excellent books.)

College Hill is essentially a large lump of rock, and to believe that a byzantine network of tunnels could be *secretly* created with eighteenth-century tools is simply ludicrous.

There are two tunnels under College Hill—a bus tunnel and a long since closed and sealed train tunnel. Perhaps some who (illegally and dangerously) wander down them get confused and decide they've discovered a slave tunnel. The construction of these two tunnels in the early decades of the twentieth century took weeks, employing explosives, heavy equipment and many workmen. Everyone for miles knew what was going on. Such work simply could not be carried out unnoticed.

To date, no one has ever come forward with solid evidence for the existence of the tunnels. They would be an important part of the city's history and culture, studied by historians and visited by tourists.

One last point is that the tunnels are obviously unnecessary. There are easier and cheaper ways to sneak people around. You wouldn't need to spend time and money on such a laborious project—it simply wouldn't be cost-effective to the merchants supposedly involved in the scheme.

But it doesn't stop people from telling stories about them anyway.

One such tale involves a ship docking in the harbor and unloading a group of slaves, who are then rushed up through a tunnel to one of the rich houses on the hill.

The man of the house was throwing a lavish dinner party when the slaves arrived, and could not get away from entertaining his guests long enough to go down to the cellar and unlock the secret door and let them in. Planning to do it later, he ate, drank and danced.

That was to be his last night on Earth. At some point in the evening, he died. One version of the story is that he choked, while another states that he suffered a heart attack or stroke. Either way, he was never able to let in the slaves.

Some say that when the full moon rises in the sky, you can still hear the slaves pounding on the door and screaming to be let inside.

EDGAR ALLAN POE AND SARAH HELEN WHITMAN

I have often said that I place little belief in haunted houses and more in haunted people. Edgar Allan Poe, the tortured genius who crafted "The Raven" and "The Fall of the House of Usher," among other dark fantasies, is such a haunted person. Poe spent so much of his brief life searching for stability and acceptance, and he may have come closest to finding those things he craved while visiting Providence.

Poe was a New Englander by birth, having been born to an itinerant theater family in Boston in 1809. When his father abandoned the family the following year and his mother died shortly thereafter, he was taken in by John Allan of Richmond, Virginia. Despite adding Allan's name to his own, he only rarely ever used it. Poe never seemed fully at home with the foster family, and he eventually broke with them completely while in his twenties. Poe then began that search for stability that would mark his entire life. He held and lost various literary and editorial jobs, drank excessively, possibly experimented with opium and other drugs, pursued several different women and eventually married his thirteen-year-old cousin, Virginia Clemm, in 1835. Virginia died of consumption (tuberculosis) in 1847, leaving Poe once again lost and bereft.

Sarah Helen Whitman was a widow (hence, she is almost always referred to as "Mrs. Whitman") who lived a shabby genteel life with her family in a modest home on Benefit Street. She was a literary eccentric who spent much time at the Athenaeum, one of the oldest libraries in the country, tracing its origins back to 1753. She was one of Providence's best-known authors at the time, a leading member of the small intellectual scene, a friend of Margaret Fuller's and a writer of poetry and essays for various publications. She often dressed in long, white scarves and shawls and veils. In fact, it was said that on blustery days, the wind would actually blow away

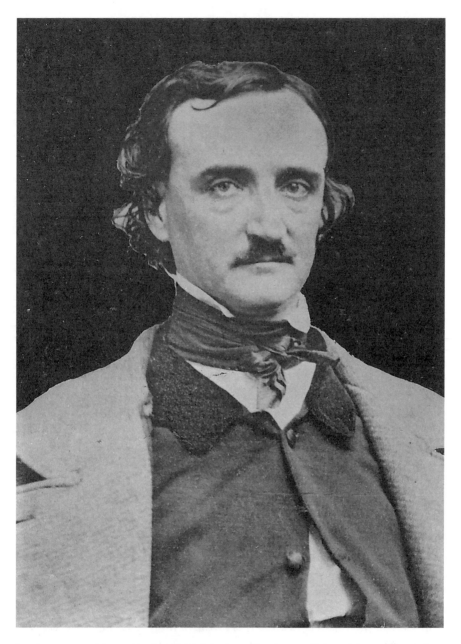

Daguerreotype of Poe, taken for Mrs. Whitman in Providence. She would not look at it for many years, feeling that it did not capture him properly, but in later years she softened her opinion of it. *Courtesy of Brown University.*

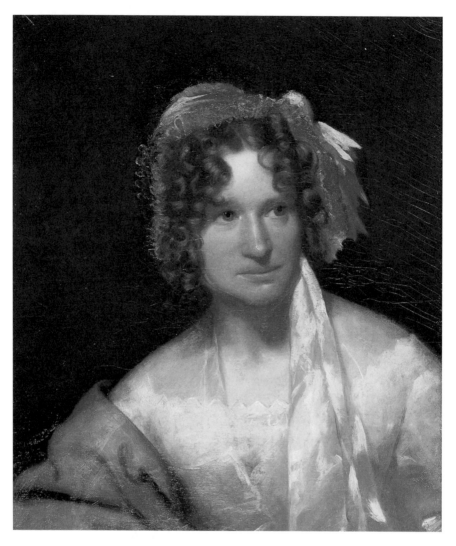

Portrait of Sarah Helen Whitman at age thirty-five (1838) by Giovanni Thompson. It hangs in the Art Room of the Athenaeum today. *Courtesy of the Providence Athenaeum.*

a veil or a scarf, but Mrs. Whitman would be too lost in thought to even notice. Understanding friends would pick up the errant article of clothing and return it to her later.

Being the literary eccentric she was, she attended spiritualist séances and mesmeric demonstrations, and supported women's suffrage and other liberal causes. A friend in Bridgeport, Connecticut, was planning to publish a spiritualist newspaper that related the mysterious and inexplicable

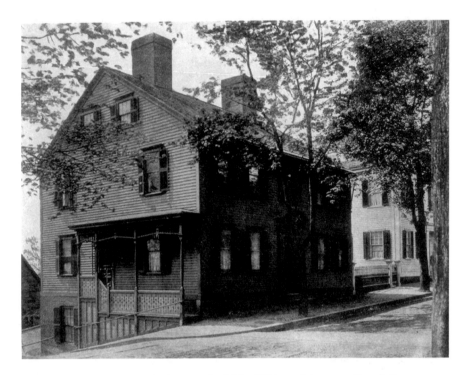

Undated (possibly circa 1918) photograph of Mrs. Whitman's home on Benefit Street, where much of her courtship with Poe was played out. *Courtesy of Christopher Martin.*

manifestations of the séance chamber and claimed: "It will be a familiar newspaper and open to communications from all intelligent spirits whether in the body or out of the body." She asked Mrs. Whitman if she would contribute "a series of familiar letters about the spirits and any other matters that may occupy your thoughts."

In 1848, she received an invitation to a literary Valentine's Day dinner in New York City where each guest was to compose a poem for the occasion, but she could not attend. She composed a poem originally titled "To E.A. Poe." She probably thought Poe would be in attendance, but he was not invited. Some time later, however, the poem was forwarded to him. It begins:

Oh! Thou grim and ancient Raven,
From the Night's Plutonian shore,
Oft in dreams, thy ghastly pinions
Wave and flutter round my door—
Oft thy shadow dims the moonlight
Sleeping on my chamber floor.

The poem contains a few allusions to Poe's work, making it clear that she was familiar with his poetry and fiction, and concludes with a poetic, Victorian come-on:

> *Then, oh! Grim and Ghastly Raven!*
> *Wilt thou to my heart and ear*
> *Be a Raven true as ever*
> *Flapped his wings and croaked "Despair"?*
> *Not a bird that roams the forest*
> *Shall our lofty eyrie share.*

Enchanted by the poem, Poe got in touch with the author, soon boarding a train to meet her in person.

When they met face to face, Poe realized that he had seen her a few years before, in 1845, when he was in Providence for a lecture. Walking along Benefit Street on the warm July evening, he had seen her in the rose garden adjoining her house, swathed in one of those flowing white gowns she favored. They nodded a greeting to one another, but did not speak. He must have been surprised to find that the woman who had sent him the poem was the same woman he had glimpsed by moonlight some time before.

Obviously, they were made for one another, and they immediately fell in love in that Gothic-cosmic way only the Victorians could, and they fairly quickly began talking about marriage. Much of their courtship was carried out in her home or, more often, in the stacks of the Athenaeum, away from the prying, disapproving eyes of her family.

One day, when Poe was visiting her at the Athenaeum, she showed him a poem entitled "Ulalume," which had been published anonymously in the *American Review*. The poem opens:

> *The skies were ashen and sober,*
> *The leaves were crisped and sere,*
> *The leaves were withering and sere,*
> *It was night in the lonesome October*
> *Of my most immemorial year*
> *It was down by the dim lake of Auber*
> *In the misty mid region of Weir,*
> *It was hard by the dank tarn of Auber,*
> *In the ghoul-haunted woodland of Weir.*

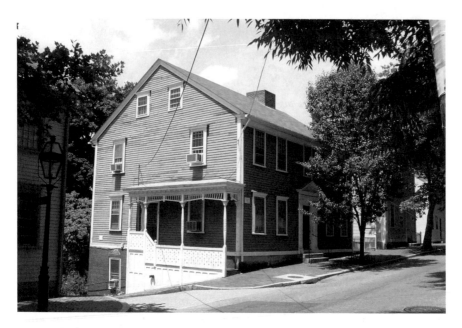

The Whitman house today. Little changed in nearly two centuries. *Photo by Robert O'Brien.*

The poem continues from there to tell the tale of a young man who is out walking one night when he stumbles across the grave of his lost love, who had died and whom he himself had buried one year ago that very night (somehow, he's forgotten about this).

Mrs. Whitman was entranced by the poem, and had asked all her friends and correspondents if they knew the author. None of them did. When she showed the poem to Poe and asked if he knew who had written it, Poe, modestly or not, said that he had, whereupon he took a pencil and signed the copy of the magazine on the table between them. That copy of the magazine, with its very small, very faded pencil autograph, "Edgar A. Poe," is still in the Athenaeum's collection over a century and a half later.

Poe even wrote her a poem entitled "To Helen," which recalled their early almost-meeting.

> *I saw thee once—only once—years ago;*
> *I must not say how many—but not many,*
> *It was a July midnight; and then from out*
> *A full-orbed moon, that, like thine own soul, soaring,*
> *Sought a precipitate pathway up through heaven,*
> *There fell a silvery silken veil of light,*

With quietude, and sultriness, and slumber,
Upon the upturn'd faces of a thousand
Roses that grew in an enchanted garden...
Clad all in white, upon a violet bank
I saw thee half reclining; while the moon
Fell on the upturn'd faces of the roses,
And on thine own, upturn'd—alas in sorrow!

He always called her "My Helen" as they walked arm in arm among the gravestones of Swan Point Cemetery, reading poetry to one another.

As one might imagine, Mrs. Whitman's friends and family were not at all pleased by this new suitor, and they did whatever they could to break up the match. Friends wrote her letters claiming that Poe was a philanderer, a drunkard or simply a madman. She ignored them. Her family asked her to sign her property over to them in the event of a marriage—she did have some money left over from her first marriage, and they didn't want Poe marrying her simply to get to her cash. She agreed, and placed her own condition upon Edgar—that he stop drinking. Poe agreed, and they began to lay plans for their wedding, and even discussed publishing a literary magazine to be titled *The Stylus*. It seemed that Poe was finally tasting the safety and security that had always just eluded him.

Until the day he showed up at the Whitman home—drunk. He told off the interfering mother. Mrs. Whitman fainted on the couch with an ether-soaked handkerchief pressed to her nose, and according to at least one version of the tale, Poe did something antisocial in their fireplace before storming out of the house and out of her life forever.

Ten months later, he was dead—he was found facedown in a gutter in Baltimore, Maryland, drunk, soaking wet and wearing another man's clothes. He was taken to a nearby hospital, where he died a few days later. His last words were said to be, variously: "I wish someone would blow my damn brains out," "God help my poor soul!" and, perhaps strangest, "Reynolds! Reynolds!"—a reference sparking much debate as to its meaning.

After his death, Poe was the target of attacks by rivals and enemies he had made during his life—he wielded a poison pen when he was in a bad mood, and many had felt the sting of his harsh criticisms. One such recipient was Rufus Griswold, who wrote a widely-reproduced defamatory obituary of Poe (which began "Edgar Allan Poe is dead. He died in Baltimore the day before yesterday. This announcement will startle many, but few will be grieved by it."), and then later a still more venomous "Memoir," which included forged letters supposedly written by

St. John's Cathedral, the Episcopalian Church behind Mrs. Whitman's house. She and Poe enjoyed walking among the eighteenth- and nineteenth-century graves where many prominent Rhode Islanders are interred. *Photo by Robert O'Brien.*

Poe. Griswold's unflattering portrait of Poe dominated public perception of the man, even to this day.

Mrs. Whitman never remarried, and never gave up on preserving the memory of Edgar Allan Poe, spending much of her time defending his name. In 1860, she published a memoir entitled *Edgar Poe and His Critics* in which she sought to refute many of the accusations leveled at Poe after his death. Its preface reads:

> *Dr. Griswold's Memoir of Edgar Poe has been extensively read and circulated; its perverted facts and baseless assumptions have been adopted into every subsequent memoir and notice of the poet, and have been translated into many languages. For ten years this great wrong to the dead has passed unchallenged and unrebuked.*
>
> *It has assumed by a recent English critic that "Edgar Poe had no friends." As an index to a more equitable and intelligible theory of the idiosyncrasies of his life, and as an earnest protest against the spirit of Dr. Griswold's unjust memoir, these pages are submitted to his more candid readers and critics by*
> ONE OF HIS FRIENDS.

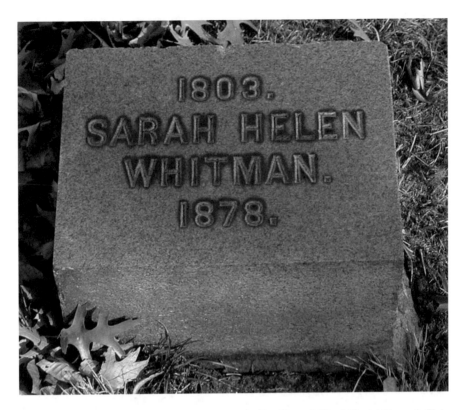

Sarah Helen Whitman's unassuming gravestone in Providence's North Burial Ground. *Photo by Christopher Martin.*

Indeed, there are many who feel that she sacrificed her reputation to save his, as she devoted her energies to salvaging his reputation. Today, while Poe and his work are discussed in classrooms the world over, Mrs. Whitman—if she is remembered at all—has been relegated to the rank of an also-ran in nineteenth-century American poetry, or simply known as one of the women with whom Poe dallied. She has, unfortunately, vanished from the pages of literature.

Along the Providence waterfront you will find a Poe Street, clearly named for the author. On certain old maps, you may also find that there was once a Helen Street running perpendicular to Poe Street. But you will only find Helen Street on a map, as it has long since disappeared—in much the same way that we remember Poe, but have long since forgotten Sarah Helen Whitman.

As one of the oldest libraries in the nation, the Athenaeum is certainly worth a visit. It was originally the Providence Library Company, housed in

A lovely old postcard of the Providence Athenaeum. *Courtesy of Louis McGowan.*

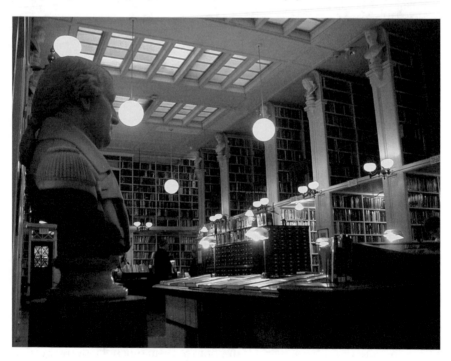

The interior of the Athenaeum today. *Photo by Christopher Martin.*

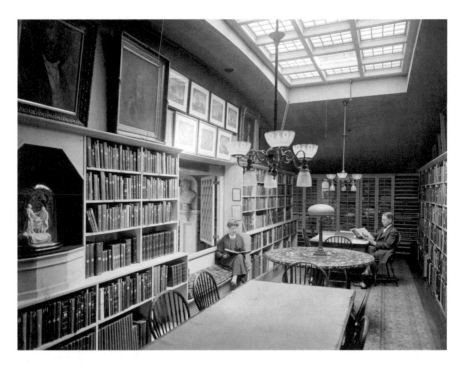

The intimate Art Room of the Athenaeum. The portrait of Mrs. Whitman hangs in this room today. *Courtesy of the Providence Athenaeum.*

one room of the Old Town House, built in 1732 on what is today Meeting Street. Nicholas Brown was the first librarian. Fires were lit in the large fireplaces for meetings of the General Assembly. Strangely, the bases of the fireplaces were made of timber, which is why the building burned to the ground on Christmas Eve 1758. Out of a collection of 345 books, the only books that survived were the 71 volumes that had been borrowed and were elsewhere at the time of the fire. For a while, the Athenaeum occupied a room in the Arcade before moving to this new building in 1836.

Stop to take a drink from the 1873 fountain outside. According to legend, if you do so, you will one day return to Providence (à la the Trevi Fountain in Rome). A more recent and cynical variation on the legend condemns the drinker to be forever trapped, unable to ever leave the city.

Visiting the Athenaeum one autumn afternoon, I asked the librarian at the desk if there were any ghost stories about the library. She looked at me as though I had asked a very foolish question indeed.

"Yes of course," she replied patiently. "Some nights, when I am here by myself catching up on some work, and everyone else has gone home, I can hear someone moving around upstairs. I hear the floorboards creak, I hear

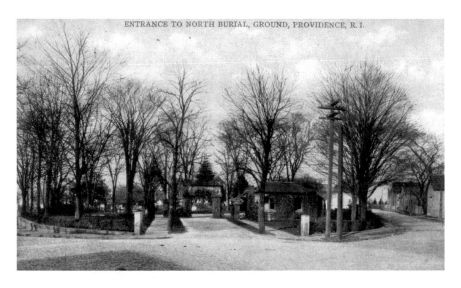

ENTRANCE TO NORTH BURIAL, GROUND, PROVIDENCE, R. I.

An old postcard of the entrance to North Burial Ground, where Mrs. Whitman lies. *Courtesy of Louis McGowan.*

books being moved and pages being turned. When I go to see who it is, there's no one there."

"And who do you think it is?" I asked.

"Poe," she said simply. "I know it must be Poe."

A young boy went to stay with his uncle on Providence's East Side while his parents were away on vacation. The first night of his visit, he saw a man in a long coat standing at the head of the stairs to the second floor, looking down at him. When the boy asked, "Who are you?" the man silently moved into a nearby room.

The boy ran to find his uncle, who was both puzzled and concerned at the prospect of a stranger being in the house. Together, they searched through both floors, but found nothing. Both did what they could to forget the strange incident.

A few days later, the boy was looking through his uncle's books—the uncle had a large library, being an English professor at one of the local colleges. The image on one book's cover made him shiver, and he brought it to his uncle, saying that the picture on the cover was of the man he had seen at the head of the stairs.

The book was the Library of America's handsome hardcover edition of Poe's works. The image on the dust jacket was the photograph he had taken in Providence for Mrs. Whitman.

Hanging an Innocent

At 150 Benefit Street you will find one of the oldest buildings on the street. This is the Old Statehouse, also known as "Providence's Independence Hall," built in 1762 as a colony house. In this building, on May 4, 1776, Rhode Island renounced its allegiance to the British Empire, a full two months before the Continental Congress in Philadelphia did so more famously. Afterwards, it was one of five statehouses where the state legislature would meet—they rotated among the five buildings until finally commissioning the Manhattan architectural firm of McKim, Mead and White to build the Rhode Island Statehouse, which stands on Smith Hill within sight of the old building. It is a building that has had a number of uses in its history, a courthouse among them. While it is not where our story begins, it *is* where our story ends.

On New Year's Eve 1843 the body of Amasa Sprague was found in a ditch by the side of the road. He had been beaten, shot and had been lying out long enough that some animal, possibly a dog, had nibbled at him. The Sprague family was an important and prominent family in Rhode Island. They owned the largest mill business in the state—the Cranston Print Works—and Amasa's brother, William, was governor. Most of the nearby city of Cranston grew up around the mills they operated.

A hue and cry went out to find the murderer—such a heinous crime against one of the state's most prominent citizens could not go unpunished.

Suspicion very quickly fell on a family of recent Irish immigrants named Gordon. One of the brothers, John Gordon, was arrested for the murder and put on trial at the building we now know as the Old Statehouse.

This is a time in history when literally hundreds of thousands of Irish were flooding into New England to escape poor conditions and famines at home, many seeking work in the mills. As the new arrivals, they were

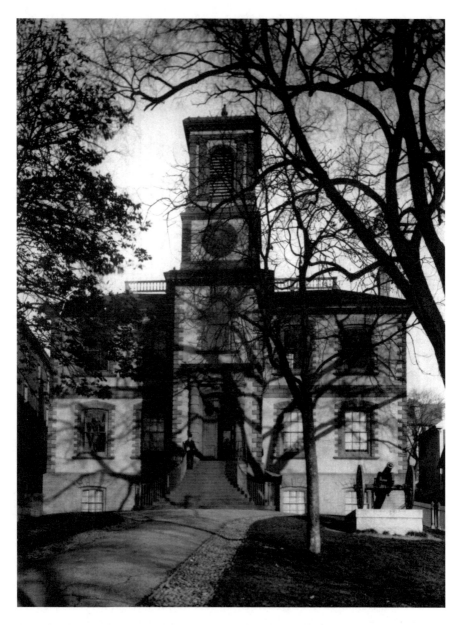

An undated atmospheric photograph of the Old Statehouse. *Courtesy of Larry DePetrillo.*

of course looked down upon by the old Yankee establishment. They were considered ignorant, superstitious, drunken and—perhaps worst of all—Catholic. Being the latest arrivals, they were easy to scapegoat. Anyone who thinks debates over immigration are a recent phenomenon should look back a century or two.

In Rhode Island during the 1840s there was also no formal police force. Citing English Common Law, a sheriff could organize a *posse comitatus* consisting of ordinary citizens to assist in investigating crimes. Once suspicion fell on John Gordon—and it fell upon him very quickly—no alternative theories were suggested or investigated. The posse essentially set out to prove his guilt. So there were a number of very interesting points about this case that came to light during the trial.

For instance, there were footprints in the snow, leading away from the body. Following the footprints, they were found to lead toward John Gordon's house—a fact the men of the posse decided must prove Gordon's guilt. However, the footprints did not lead into the house, but continued past it. No one bothered to follow the trail the rest of the way. Getting as far as Gordon's house was evidence enough for a posse that had already made up its collective mind.

There was a broken gun lying a short distance from the body. John Gordon owned a gun, which he said he had lost some time previously. People simply assumed he had lost the gun in the struggle on the night of the murder. The gun that was found, however, was never shown to have been the one belonging to the accused.

Two strangers were seen that day shortly before the murder, one of them carrying a gun. No attempt was ever made to trace these individuals.

The trial lasted for nine days, and John Gordon was convicted of the murder of Amasa Sprague and sentenced to be hanged in the yard of the state prison, which stood on the site of the present-day Providence Place Mall. The Irish were an unpopular ethnic minority, and unpopular ethnic minorities always suffered the death penalty more often. Evidently, little has changed in over a century and a half.

Gordon was hanged on Valentine's Day 1845. The funeral procession of some fourteen hundred people wended its way through the streets of Providence, passing right down Benefit Street, right past the courthouse where John Gordon was condemned. It took the cortege half an hour to get through one intersection and continue on to North Burial Ground where he was originally buried. His body was later moved.

We know today that John Gordon was innocent. After the trial, new evidence was found and new witnesses came forward offering exculpatory

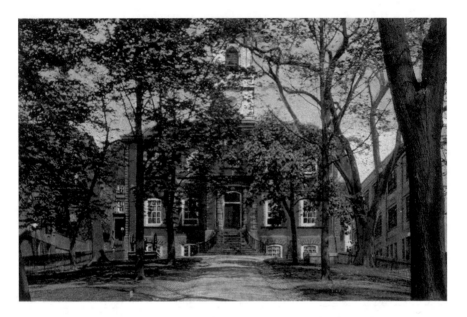

A postcard of the Old Statehouse, part of the "Historic America" series. *Courtesy of Louis McGowan.*

information. No one knows who murdered Amasa Sprague, but we know that it was certainly not John Gordon.

The leading theory is that the guilty party was Amasa's brother, William Sprague, who sought to eliminate his brother to take over his half of the family business. While only speculation, it remains the most frequently cited theory of the crime.

In 1852, partially because of this case and new evidence that came to light, Rhode Island abolished the death penalty. There is no death penalty to this very day, because the last time the death penalty was handed down, an innocent man was hanged—the victim of racial intolerance, class prejudice and mob mentality.

Some years ago, the Old Statehouse building was being worked on and it was sheathed in scaffolding. A workman was up on the third floor, working on a window, and he turned around to pick up a tool. There was a figure on the platform behind him—a man wearing what was described as "old fashioned black clothes."

Somehow, the worker knew the figure wasn't really there.

I have heard two versions of the story—one is that the workman said to the figure "Good day," and the other is that the figure similarly greeted the

workman. Whichever the case, one spoke to the other, the workman took a deep breath and then went back to what he was doing. When he turned back a moment later the figure was gone.

One of the women who works in this building tells me she thinks it was the ghost of John Gordon. This was during the same time when work on the new Providence Place Mall had just begun, and preliminary archaeological excavation on the site uncovered the old foundations of the prison where John Gordon was hanged. Interestingly, they also found one human skull, and no one knows to whom it belonged or what it was doing there.

Is it possible that John Gordon, years after his wrongful execution, was disturbed by the work on the site of his death and returned to haunt the site of his condemnation?

If you visit the Old Statehouse—and you should—you can stand in the very courtroom where the trial took place. It is a strangely peaceful and quiet room, despite the many conflicts that must have played out there. The room does not look as it did in John Gordon's day.

Take a look at the witness stand—you may see a spot where the wood has been worn down, seemingly by human fingers. I wonder if this was done in one dramatic gouging, or if some poor soul gave testimony over several days, nervous fingers working their way down into the wood with unconscious, terrified drumming.

THE BURNSIDE MANSION

When I first began collecting ghost stories several years ago, a number of friends said, "You know about the Poe house on Benefit Street, right?"

Asking for more detail, they directed me to the house pictured here, on the corner of Benefit and Planet Streets.

When pressed further, specifics were not forthcoming. Poe lived there, I was told. Or possibly his niece. Or his daughter. Or his mistress. Nobody was quite sure, but they were certain that there was a connection of some sort.

This is the General Ambrose Burnside mansion. Burnside was a Civil War general probably best remembered for his long, bushy side whiskers from which we get the term sideburns. This house was built in 1866, some sixteen years after Poe's death, so there is no Poe connection.

To the best of my knowledge it is not haunted. I am indescribably disappointed.

But I think that if it were haunted, it would be by any number of the thousands of boys and men Burnside got killed during his thoroughly disastrous tenure as a general. When he was eventually relieved of his command and sent back to Providence, he was given a hero's welcome, elected governor and later senator. Today, there is a statue of him in downtown's Burnside Park.

This world may have forgiven him, but I wonder about the souls he had to face in the next.

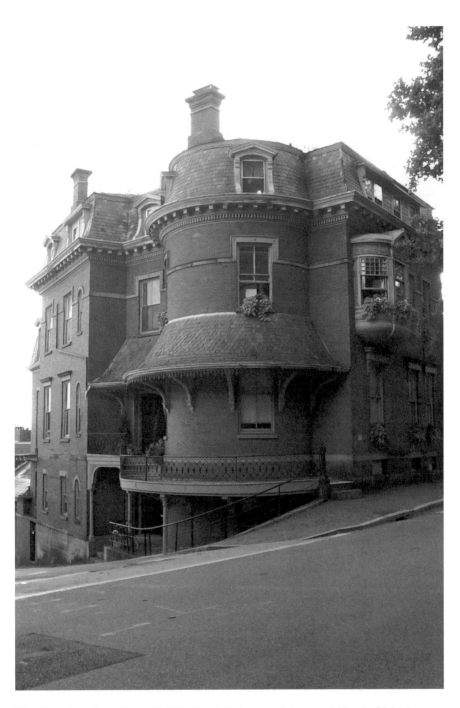

The General Ambrose Burnside Mansion. It isn't haunted, but much like the Lightning Splitter House, it fits the image of a haunted house almost perfectly. *Photo by Robert O'Brien.*

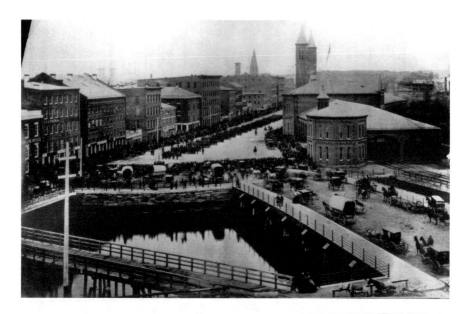

Downtown Providence, with columns of troops departing for the Civil War. *Courtesy of Lawrence DePetrillo.*

THE TERRIBLE TALE OF
THE TURK'S HEAD

Not all of the stories collected here are ghost stories. Some are simply strange. Early Providence grew up on the eastern side of the river that ran through it. The western side remained largely undeveloped for many years. One of the early adventurous souls who settled the far shore was Jacob Whitman (no relation to the gifted poet and fleeting fiancée of Edgar Allan Poe), who in 1763 reared his home at the fork of Westminster and Weybosset Streets, new streets said to be laid out along old Native American trails.

On a post outside his home, Whitman placed a curious wooden figure—a carving of a leering Ottoman warrior, complete with a jutting beard and huge turban, his tongue thrust out defiantly between his square teeth. Some said it was the figurehead of an old merchant ship. Others supposed it to be a copy of a sign seen somewhere in London. Unsurprisingly, the timber Turk frightened the children, many of the women and caused general excitement and comment. Whitman's home quickly became known simply as "the Turk's Head."

Whitman ran a shop out of the first floor of his house, a common arrangement at the time, and chose to display this Turk rather than the more common wooden American Indian often seen outside tobacconists and other establishments catering to largely male clientele.

Soon enough, the area itself became known as the Turk's Head, whether the neighbors liked it or not.

Providence has been pummeled by several dramatic hurricanes over the centuries, and the Great Gale of 1815 was one of the worst. Whitman's establishment was flooded by six feet of water, and the infamous Turk's Head was carried away by the rising tide.

A few days later, Whitman's son, Jacob Whitman II, was out in a boat salvaging some of their property from the flotsam when he found the

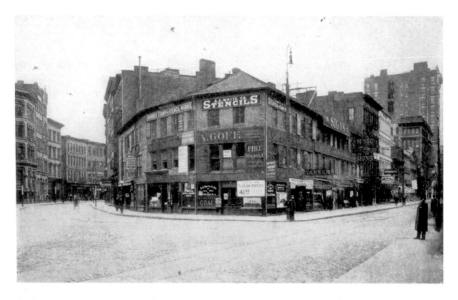

A photograph (circa 1918) of Whitman's Block, one of the succession of buildings that stood on the site of his original house and shop with the famed Turk's Head. *Courtesy of Christopher Martin.*

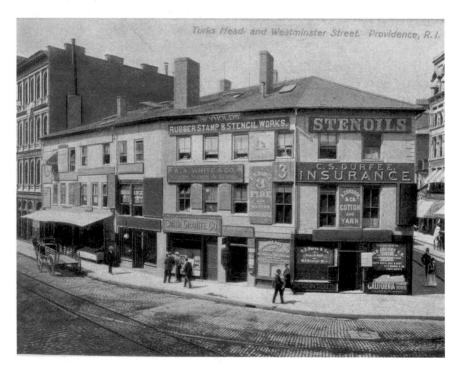

Another view of Whitman's Block, from an undated postcard. *Courtesy of Louis McGowan.*

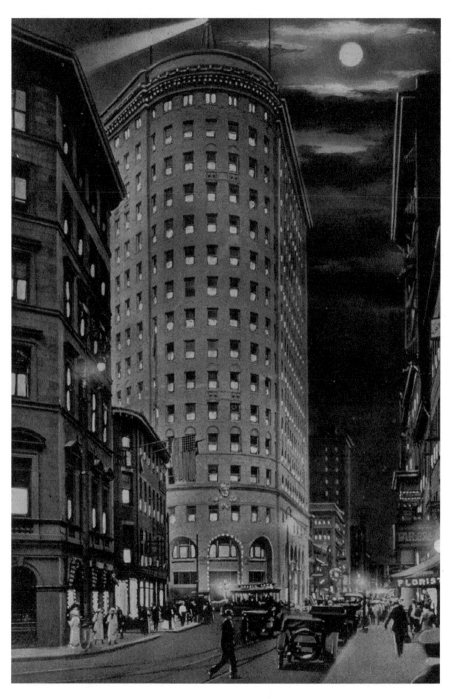

A beautiful art deco view of the newest Turk's Head Building, showing a lively downtown nighttime scene and (strangely) some kind of searchlight atop the building. From an old postcard. *Courtesy Louis McGowan.*

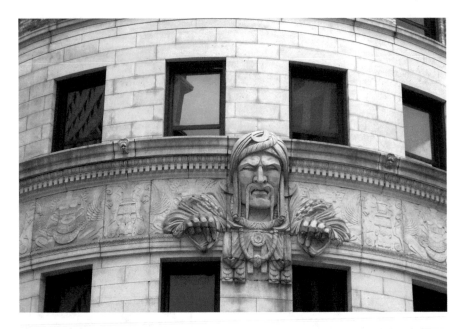

Today's Turk's Head in granite, glowering at passersby. *Photo by Robert O'Brien.*

Turk bobbing among the waves. Perhaps deciding that the Turk had seen enough adventure, he stowed it under the stairs of his house for a number of years.

When his son George opened a business in Montgomery, Alabama (the Whitmans obviously were an industrious and entrepreneurial clan), Jacob II sent him the Turk's Head, which was proudly displayed outside the new enterprise. Once more it frightened passersby, much as it had in Providence, and again garnered its owner a good deal of word of mouth notoriety.

One night, a band of carousing young men stumbling out of a nearby saloon stole the Turk and mailed it to the governor of Alabama with a note claiming it was the head of a Native American chief they had captured.

The head was eventually restored to George Whitman, who put the Turk back in its accustomed place over his shop until he retired from business some years later. The Turk's Head was then placed in a warehouse in New Orleans, where Whitman had relocated his business in later years. Unfortunately, the warehouse burned after only a few years, and all its contents were lost.

That is, all except for possibly the Turk's Head. There is a strange tradition that it somehow escaped the fire and was passed to a group of Cherokee Indians, who continue to worship it as an idol to this very day.

Whitman's store is long gone, of course. In 1912, an impressive sixteen-story building was reared on the site, its *V* shape fitting neatly into the fork of Westminster and Weybosset Streets. At the time, it was the tallest building in the state. It is still called the Turk's Head Building.

As you walk past the building, look up—you will see a leering granite Ottoman looking back at you, every bit as fierce as the original wooden carving, but happily more durable. And the architectural historians among you will say that he is not a gargoyle—he is properly known as a grotesque.

ANNIE OF THE ARCADE

The Arcade, an impressive Greek Revival edifice a few doors down from the Turk's Head Building, is the oldest shopping mall in the country—a forerunner of the department stores that would blossom a century later. Built in 1828, when there were few shops on the west side of the river (Whitman's was also among the few), it has become a familiar landmark. Said to be based on the Madeleine of Napoleon in Paris, several other similar shopping arcades were built around the country, but the one in Providence is apparently the only survivor. The work of two different architects, Russell Warren and James Bucklin, the building runs through an entire city block, from Westminster Street to Weybosset Street. According to legend, the two architects could not agree on some aspects of the design, which is perhaps why each façade of the building has a different roofline.

Upon opening, it attracted merchants who rented shop space there, but was slow to attract customers for its first few years. The best shops were still on the East Side and the largest were in Cheapside—both locations were on the opposite bank of the river, so there was little motive to venture across the bridge. In fact, the building was for many years called "Butler's Folly," after the builder, Cyrus Butler, because of its distance from what were then the retail districts.

All that changed when a hat shop run by three sisters opened its doors and attracted the attention of well-heeled ladies, who flocked to the Arcade for the latest fashions in millinery. Those three sisters and their shop can be largely credited with spurring the growth of the area we know today as downtown.

Among the clients at the shop was the daughter of a wealthy East Side family known only to us as Annie, her surname having been lost long ago. Annie was hopelessly in love with James, who came from a working-class

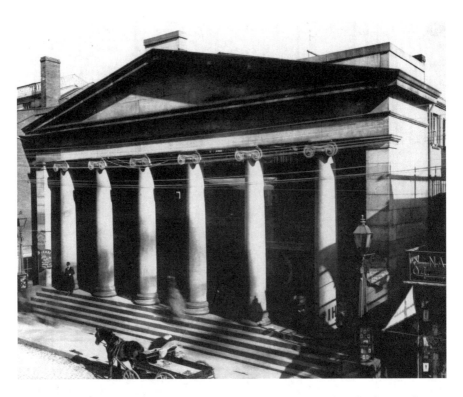

Late nineteenth-century view of the Westminster Street end of the Arcade. *Courtesy of Lawrence DePetrillo.*

family that ran a small shop a few streets away, being of modest means and unable to afford space in the Arcade.

Predictably, Annie's family forbade their daughter to dally with someone who they regarded as a mere tradesman, so the two lovers met at the Arcade, where they would stroll, arm-in-arm, along the balconies. There was talk of an elopement.

A shopkeeper in the Arcade, perhaps hoping to curry favor with Annie's family, informed her mother of the assignations, and thereafter Annie was not allowed out except under strict family supervision. A few secret meetings were attempted but foiled by her vigilant family.

Saddened, James signed aboard a merchant ship and left for the Orient, perhaps hoping to return to Providence rich enough to win the approval of Annie's intractable family. Unfortunately, his ship went down rounding the Horn, and all hands were lost.

Annie spent the rest of her life waiting for James's return. Whether she gave up her vigil we don't know, but she never married and she rejected

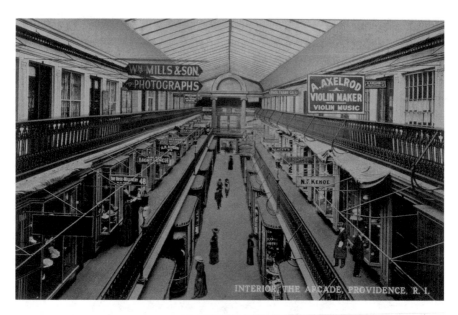

A beautiful postcard view of the Arcade's interior. *Courtesy of Louis McGowan.*

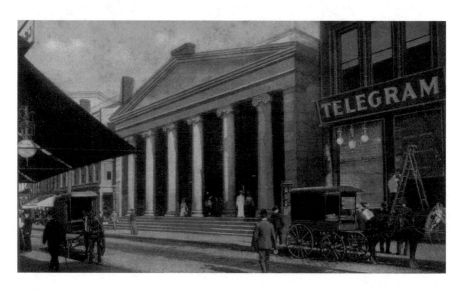

A postcard view of the Westminster Street side of the Arcade. The telegraph office at right would, among other things, post the current scores of baseball games in its window. *Courtesy of Louis McGowan.*

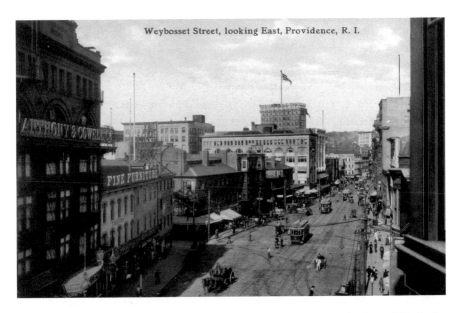

A lively and bustling Weybosset Street, demonstrating that commerce and culture did indeed eventually cross the river from the East Side. *Postcard courtesy of Louis McGowan.*

A postcard view of nineteenth-century downtown Providence, obviously during a golden age of advertising. *Courtesy of Louis McGowan.*

suitor after suitor steered toward her by her parents. Annie remained an old maid long after the last of her sisters married and moved away.

Some say that her secret meetings with James continue from beyond the grave, and that they may still be seen strolling arm-in-arm along the third level of the Arcade, which was one of their favorite spots.

A shopkeeper in the Arcade told me that one day she was alone in her little shop, on the phone with a customer, when she heard the door open—she had a set of small bells on the doorknob. She glanced over at the woman entering the shop, nodded politely and whispered, "I'll be with you in just a minute."

The young woman who entered wore a big hat, a tight-buttoned coat and a skirt that reached the floor. The shopkeeper thought it was a strange outfit for an August afternoon. The woman smiled sadly and started to browse among the merchandise as the shopkeeper turned around to finish the phone conversation. Hanging up the phone, she turned back to her new customer, but she was gone.

Puzzled, she went outside to the balcony to see if the woman had slipped outside, but she saw no sign of her. Another shopkeeper was standing outside of his shop, and the woman asked him if he had seen a woman in a big hat and skirt exiting her store.

"No," the man said.

The woman went back into her shop, closing the door and hearing the bells jingle, not quite able to believe that she had just seen a ghost.

When visiting the Arcade, look upward. If you see two shadows gliding along, smile and wish them well.

H.P. Lovecraft

Howard Phillips Lovecraft was born on August 20, 1890, the only child of Winfield Scott Lovecraft, a traveling salesman for Providence's Gorham Silver Company, and Sarah Susan Phillips, daughter of an East Side family that had seen better days. He was born at 454 (back then it was 194) Angell Street, where his mother lived with her father, Whipple van Buren Phillips.

"Susie," as she was called, had wanted a girl, so she dressed him in girls' clothes and kept his hair long for several years. He has often been described as a "sickly" child, but one wonders if he truly was, or if that was his neurotic mother's assessment.

A precocious child, he was reading by age four and began writing by around age six. Reading through his grandfather's library, he discovered Classical Greek and Roman authors, astronomy and the *Arabian Nights*. Grandfather Phillips, who encouraged the boy to read and write, often entertained his grandson with extemporized tales of Gothic mystery and horror, and probably helped fill the void left by the often-absent father.

In 1893, Winfield Scott Lovecraft suffered a nervous breakdown in Chicago and was brought back to Providence and admitted to Butler Hospital, a psychiatric facility not far from the family home. He was never discharged, and died there five years later. The diagnosis was "paresis," a Victorian term for the paralysis and dementia that accompany end-stage syphilis. Apparently, at least some of the stories about traveling salesmen are true.

In the financial crisis precipitated by the death of Whipple Phillips in 1904, Susan lost the family home, and she and her young son moved into more modest digs down the street. Financial uncertainties would dog Lovecraft for the rest of his life.

H.P. Lovecraft (August 20, 1890–March 15, 1937). *Courtesy of Brown University.*

Lovecraft's education was sporadic at best, with Susan pulling him out of school for extended periods because of his supposed poor health, but he continued to read voraciously on his own. He pursued his interest in astronomy, writing articles for the *Providence Journal* while still in his teens, and was such a frequent visitor to Hope Street's Ladd Observatory that he was given his own key.

His hopes of attending nearby Brown University, a school he felt offered what he probably saw as a fittingly refined education, went unrealized. He never even completed Hope High School. Later in life, he would make vague references to some manner of breakdown occurring about this time (1908). This is the beginning of what has been called his "blank period," lasting until about 1912. During this time, he led a reclusive, largely nocturnal life. He would venture out at night, roaming Providence's lonely streets and developing a deep attachment to the old city.

As he grew older, much of his time was occupied by writing letters—some of them running thirty or forty pages—to a growing circle of correspondents. He also wrote a great deal of fairly awful poetry, mostly based on eighteenth-century British models such as Pope and Dryden.

A lifelong Anglophile, he occasionally declared that the United States, or at least New England, should return to British rule, and sometimes punctuated such statements with "God save the King!" He also used British spellings in his writing—*colour*, *centre* and so on.

His self-image as a cultured eighteenth-century white, Anglo-Saxon, Protestant gentleman resulted in some views that were condescending at best and intolerantly racist at worst. Some have attempted to downplay Lovecraft's harsher views, claiming they were not at all uncommon for someone of his time and class. But his views really could be quite extreme, despite these efforts to gloss over the more unpalatable aspects of his character. On his moonlit strolls through Providence, he would often walk far out of his way to avoid neighborhoods of "foreigners." Immigrants, many of them Italian or Portuguese, simply did not fit into Providence as he saw it. He felt they did not understand or respect genteel Yankee culture.

He began to produce weird horror fiction, publishing in some of the pulp magazines of the day, such as *Weird Tales* and others. This brought in a little bit of money, and broadened his circle of correspondents (the so-called "Lovecraft Circle," where Lovecraft assumed an avuncular role, encouraging younger writers). Some of the later-famous writers with whom he maintained close contact via the mail included the teenaged Robert Bloch, who would later write *Psycho*; August Derleth, who would later declare himself Lovecraft's protégé; and Robert E. Howard of Texas,

creator of Conan the Barbarian and a prolific author of pulp stories. Although the two never met, Lovecraft and Howard became close friends through their many letters.

An avid local historian and folklorist, Lovecraft set many of his stories in Providence or greater New England, and often incorporated real local historical events or figures into his narratives to add verisimilitude to the fantastic events they describe. This has led some unwary readers to assume that the tales are perhaps more true than they actually are.

One example is his invention of the *Necronomicon*. Written by the "Mad Arab" Abdul Alhazred (a name Lovecraft used during his childhood *Arabian Nights* phase), this is supposed to be a grimoire of evil knowledge and sorcery, which drives its readers mad. Many booksellers over the years have been asked for a copy of the dangerous tome. Years ago, some prankster slipped a card for the book into Yale University Library's card catalogue. Several enterprising publishers have released books said to be Alhazred's blasphemous work. The last time I checked, some half-dozen different books were available under the title.

Many of his stories used what has been called the "Cthulhu Mythos," a term never actually employed by Lovecraft himself. The Mythos stories concern alien gods and their cultists (Cthulhu being one of the biggest and meanest) seeking to wreak havoc on time and space—or at least on Providence. He is often credited with creating the genre of cosmic horror (sometimes, cosmic terror), the vision of mankind's ultimate insignificance in a vast unfathomable universe that was indifferent at best, and overtly hostile at worst.

A skeptical materialist, Lovecraft often expressed his contempt for any form of religion or supernaturalism. One wonders what he would make of those who have since claimed him as some sort of ascended master truly in touch with the elder gods.

Like her husband before her, Susan Lovecraft was admitted to Butler Hospital after a nervous breakdown in 1919. She died there two years later due to complications from a gallbladder operation. Lovecraft took her death hard, as might be imagined. Prone to fits of depression and neurosis himself, and now having lost both parents to mental illness, the specter of madness would always haunt him, and he often feared ending his days at Butler also.

Within a few weeks, he had recovered sufficiently from his shock to attend an amateur writers meeting, where he met Sonia Haft Greene, another writer, from New York City. The fact that Sonia was a Ukrainian Jew didn't seem to bother him, and the two were married in 1924.

Lovecraft moved to New York, where Sonia ran a hat shop. Lovecraft, who had never held a job in his life, began to look for work with a predictable

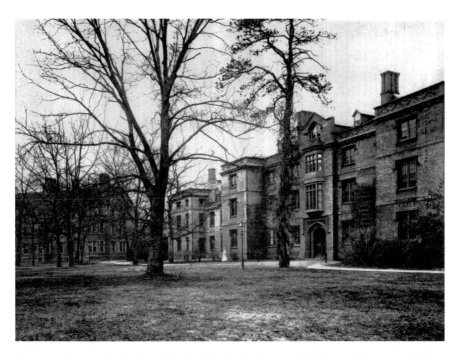

A stern and atmospheric view of Butler Hospital, where each of Lovecraft's parents died. He spent much time worrying that he might ultimately share their fate. *Photograph courtesy of Lawrence DePetrillo.*

An unusual photograph of a smiling Lovecraft. One wonders what was the joke (or the occasion). *Courtesy of Brown University.*

lack of success. (I have come across one reference to Lovecraft taking a job at the ticket window of a movie theater in Providence, selling tickets for the midnight showing. The idea of buying a ticket to the midnight show from H.P. Lovecraft makes me chortle in my glee.)

Sonia's hat shop failed, Lovecraft was unwilling to accept jobs he felt were beneath a gentleman and his xenophobia reached a new height among the immigrants of New York. He missed his beloved Providence. His aunts forbade him to bring Sonia back to Providence with him. It is uncertain what they disapproved of more—that Sonia had run a shop and therefore was a tradeswoman, or that she was Jewish. When Sonia left to take a job in Cleveland, he stayed behind in Brooklyn before returning to Providence in 1926. The couple divorced amicably in 1929.

Back in Providence, Lovecraft moved into an apartment at 10 Barnes Street, where he continued to read, write and take on jobs as a ghostwriter to help supplement his meager income. His list of ghostwriting clients included Harry Houdini.

After the death of his aunt Lillian Clark in 1932, he moved in with the surviving aunt, Annie Gamwell, at 66 College Street on the crest of College Hill, overlooking the city. Here he produced some of his best-known stories, such as "The Haunter of the Dark" and "The Shadow Out of Time." He published more widely, and his circle of correspondents grew.

The winter of 1936–7 was a bad one for him, as he suffered from various health complaints, including sometimes excruciating abdominal pains. He probably knew what was wrong, but chose to ignore his symptoms for as long as he could before finally entering Jane Brown Hospital in March 1937. He was diagnosed with intestinal cancer and Bright's disease, an inflammation of the kidneys. He died a few days later on March 15, 1937, at forty-seven years of age.

Lovecraft's funeral was attended by only four people, and he was laid to rest in the Phillips family plot in Swan Point Cemetery, next to his parents and grandfather, with his name carved into the family's obelisk.

In 1977, after years of having no headstone of his own, a network of fans took up a collection. Today, there is a simple stone with his name, birth and death dates and the epitaph, "I Am Providence," taken from one of his letters.

The stone does not quite mark his actual resting place. This did not stop some deranged fans from attempting to dig him up some years ago. They failed, giving up when they hit a concrete slab several feet down.

Visiting the grave, you will often find candles, coins and other offerings left there. Some time ago, someone defaced the family marker with a graffito taken from the mythical *Necronomicon*:

Part I: Haunted Providence

That is not dead which can eternal lie;
And with the strange aeons, even death may die.

Lovecraft's fan base and reputation grew greatly after his death, achieving for him fame undreamed of during his life. French and British critics were among the first to discover his work, and their enthusiasm eventually spread back to American shores. Today, despite his often heavy-handed prose and clunky plotting, he is considered the greatest American writer of horror fiction since his idol Poe. His fiction does depict a frighteningly indifferent or even malevolent universe—a path rarely explored by others at that time, and certainly not in the pages of a pulp magazine. His work ranges from macabre short stories, weird poetry (including a sonnet cycle, *Fungi From Yuggoth*), his bizarre "dreamlands" stories (drawing extensively on his own dreams) and the Cthulhu Mythos. Many of his stories mix genres freely, with his horror tales incorporating science fiction motifs.

One theme running through many stories is his deeply-felt attachment to Providence—some sections of his novel *The Case of Charles Dexter Ward* are literally love letters to the city. The description of Ward's return to his hometown after several years away is a very thinly-disguised account of Lovecraft's own homecoming from New York:

> *That return did not, however, take place until May 1926, when after a few heralding cards the young wanderer quietly slipped into New York on the Homeric and traversed the long miles to Providence by motor-coach, eagerly drinking in the green rolling hills, and fragrant, blossoming orchards, and the white steepled towns of vernal Connecticut; his first taste of ancient New England in nearly four years. When the coach crossed the Pawcatuck and entered Rhode Island amidst the faery goldenness of a late spring afternoon his heart beat with quickened force, and the entry to Providence along Reservoir and Elmwood Avenues was a breathless and wonderful thing despite the depths of forbidden lore to which he had delved. At the high square where Broad, Weybosset, and Empire Streets join, he saw before and below him in the fire of sunset the pleasant, remembered houses and domes and steeples of the old town; and his head swam curiously as the vehicle rolled down to the terminal behind the Biltmore, bringing into view the great dome and soft, roof-pierced greenery of the ancient hill across the river, and the tall colonial spire of the First Baptist Church limned pink in the magic evening against the fresh springtime verdure of its precipitous background.*

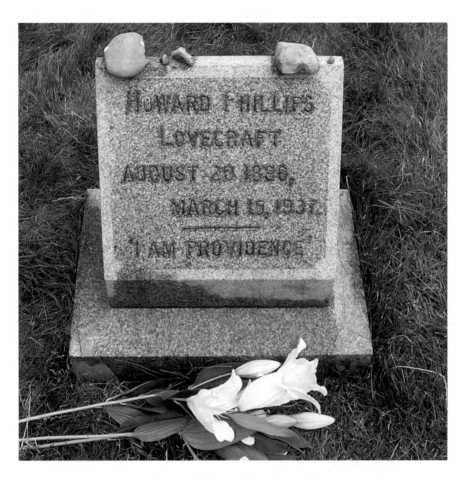

"I Am Providence"—Lovecraft's grave in Swan Point Cemetery, with a few of the many offerings that are usually left there, much to the consternation of the custodians. *Photo by Robert O'Brien.*

Old Providence! It was this place and the mysterious forces of its long, continuous history which had brought him into being, and which had drawn him back toward marvels and secrets whose boundaries no prophet might fix. Here lay the arcana, wondrous or dreadful as the case may be, for which all his years of travel and application had been preparing him. A taxicab whirled him through Post Office Square with its glimpse of the river, the old Market House, and the head of the bay, and up the steep curved slope of Waterman Street to Prospect, where the vast gleaming dome and sunset-flushed Ionic columns of the Christian Science Church beckoned northward. Then eight squares past the fine old estates his childish eyes had known, and the quaint brick sidewalks so often trodden by his youthful feet.

Part I: Haunted Providence

The College Hill neighborhood as Lovecraft would have known it on his nighttime strolls. *Postcard courtesy of Christopher Martin.*

And at last the little white overtaken farmhouse on the right, on the left the classic Adam porch and stately facade of the great brick house where he was born. It was twilight, and Charles Dexter Ward had come home.

Whatever shortcomings he had as a writer—thin characterizations, lack of dialogue, a tin ear for local accents, predictable plotting, a marked tendency to overwrite resulting in prose laden with often obscure polysyllabic adjectives—he could occasionally be quite eloquent when the spirit moved him.

He has been the subject of academic studies and several weighty biographies. Many modern authors continue to use his Cthulhu Mythos in their own fiction—something that Lovecraft encouraged among the Lovecraft Circle during his life. Stephen King and others have cited him as an influence and sprinkled some of their own fiction with Lovecraftian references. Rod Serling dramatized "Cool Air" and "Pickman's Model" for his *Night Gallery* television series, and used Lovecraftian elements in two more segments. A California rock band has adopted his name, and he has inspired a number of movies, few of which bear any resemblance to his work.

Not bad for a local boy.

Roger Williams watches over the city he founded from the memorial at Prospect Terrace, where Lovecraft spent much time. Williams's remains are entombed in the base of the monument. *Photograph by Robert O'Brien.*

A SHORT GUIDE TO LOVECRAFTIAN PROVIDENCE

454 Angell Street: The ancestral home where he grew up with Susie and Whipple Phillips. The house is long gone, and there is now a Starbuck's on the site. Order your grande fair trade Americano blend, make eyes at the barista and listen for the sound of Lovecraft rolling over in his grave.

598 Angell Street: Susie and little Howard moved into one of the apartments here after Whipple Phillips's death in 1904. He would live here for over twenty years, until his departure for New York.

Prospect Terrace, Congdon Street: This park, smaller in Lovecraft's time, was a favorite spot of his. He could often be found here with a book, looking out over his beloved Providence.

The statue of the state's founder, Roger Williams, which Henry L.P. Beckwith, author of *Lovecraft's Providence and Adjacent Parts*, has described as being "in a style which might be termed Socialist Monumental," marks Williams's final resting place. The statue and Williams's remains were not here until 1939, two years after Lovecraft's death.

The Fleur de Lys Building at 7 Thomas Street—a fantastic building in every sense of the word. *Photograph courtesy of Ken Pastore.*

Howard Phillips Lovecraft

(1890 - 1937)

U.S. Author

I never can be tied to raw new things,
For I first saw the light in an old town,
Where from my window huddled roofs sloped down
To a quaint harbour rich with visionings.

Streets with carved doorways where the sunset beams
Flooded old fanlights and small window-panes,
And Georgian steeples topped with gilded vanes –
These are the sights that shaped my childhood dreams.

Dedicated on the Centennial of his birth
August 20, 1990
by
The City of Providence
Brown University
and
Friends of H.P. Lovecraft

The plaque outside the John Hay Library. *Photo by Robert O'Brien.*

7 Thomas Street, the Fleur de Lys Building: Built by artist Sidney Burleigh in 1885 as studio space for himself and his fellow artists, this building became a part of the turn-of-the-century art scene.

Charlotte Perkins Gilman, author of *The Yellow Wallpaper* (much admired by Lovecraft) and *Herland* among other works, attended the Rhode Island School of Design (RISD) and lived in Providence with her artist husband

Charles Walter Stetson, who had a studio here. She makes several mentions of visiting her husband at his studio, and while she does not specifically say that it is in this building, it seems likely.

In the story "The Call of Cthulhu," Lovecraft has a young RISD student, Henry Anthony Wilcox, living here. Wilcox is prone to bizarre dreams, and after waking from one, he sculpts *A Horror in Clay*, the first indication that the Great Old One, Cthulhu, is still active.

Although married, Sidney Burleigh is said to have carried on several affairs, most notably with a talented landscape painter named Angela O'Leary. The affair must have ended badly, for Angela O'Leary gassed herself to death one night here in December 1921. Her ghost is said to occasionally roam the halls, and I have spoken with a local artist who claims to have encountered her one cold winter night.

10 Barnes Street: Lovecraft took a modest apartment here upon his return from New York in 1926. According to *Lovecraft: A Biography* by L. Sprague de Camp (Doubleday, 1974): "In 1971, an undergraduate at Brown, rooming at 10 Barnes Street, reported seeing HPL's ghost in the building."

140 Prospect Street: The Halsey Mansion. Located just around the corner from the Barnes Street apartment building, this is the address given as the home of the protagonist in *The Case of Charles Dexter Ward*, Lovecraft's short novel. Young Ward bears a strong resemblance to the author.

According to de Camp: "At one period, when the house had stood empty for a time, it was reputed to be haunted by a piano playing ghost, and to have an inexpugnable bloodstain on the floor."

Beckwith, on the other hand, states: "Persistent rumors that the building is haunted may or may not be true."

Haunted or not, in the nineteenth century this was the home of "Wild" Tom Halsey, a rake, bon vivant and one-time consul at Buenos Aires (which is apparently when the house was empty). Henry Clay wrote: "No man lived higher than he. He loved terrapin soup, and I recollect that he used to keep the live terrapins in the cellar of the mansion house on Prospect Street."

65 Prospect Street: Lovecraft's last address, this house was originally located at 66 College Street, right behind the John Hay Library, before being moved in September 1959 to make way for Brown University's List Art Building. The modernist design of the List probably would have set Lovecraft's teeth on edge.

Another sight Lovecraft would have seen—the 1928 construction of the Industrial Trust Bank Building, also known as the Superman Building. The top few floors of the Turk's Head Building can be seen to the left. *Photo courtesy of Lawrence DePetrillo.*

187 Benefit Street: Now a RISD dorm, this was Horace B. Knowles & Sons Funeral home, where Lovecraft's wake and funeral were held. Many stories of strange paranormal goings-on in the building persist, much like any college dorm.

John Hay Library: Named for a prominent Providence citizen who often attended spiritualist séances, the Hay has the largest collection of Lovecraft material in the world.

I have been told by someone who worked here as summer help that the room containing the Harris Collection of American Poetry and Plays is haunted, with numerous strange sounds emanating from the locked, empty room. I have not substantiated another tale that the library has in its collection a book bound in human skin.

In August 1990 a memorial plaque dedicated to Lovecraft's memory was placed on the library grounds to mark his hundredth birthday.

Where to place the plaque had been the cause of some minor controversy. Some (such as the present author) favored Prospect Park, one of Lovecraft's favorite places. The city felt it inappropriate to place a monument honoring an individual in a city park unless the entire park was dedicated to said individual. This ignores the fact that there are several such monuments in Providence's largest and most beautiful park, Roger Williams Park—one being in honor of Abraham Lincoln. After much back-and-forth, the plaque was finally placed here, on a spot that is not city property.

This, unfortunately, is another example of Lovecraft being held at arm's length by the city he loved so much.

THE SHUNNED HOUSE

Number 135 Benefit Street is a pleasant private home painted a cheery yellow that was owned by colonial merchantman Samuel Harris in the 1760s. Lovecraft used this house as the setting for his 1924 story, "The Shunned House." As it is one of his best-known tales and a house with stories in its own right, it warrants a separate entry. It is a prime example of Lovecraft incorporating local color and lore into his fiction.

The story opens with a description of Poe's visits to Mrs. Whitman, and his walks along Benefit Street:

> *Now the irony is this. In this walk, so many times repeated, the world's greatest master of the terrible and the bizarre was obliged to pass a particular house on the eastern side of the street; a dingy, antiquated structure perched on the abruptly rising side hill, with a great unkempt yard dating from a time when the region was partly open country. It does not appear that he ever wrote or spoke of it, nor is there any evidence that he even noticed it. And yet that house, to the two persons in possession of certain information, equals or outranks in horror the wildest phantasy of the genius who so often passed it unknowingly, and stands starkly leering as a symbol of all that is unutterably evil.*

I have already described the story that some bodies remain from the time when small family plots dotted the neighborhood. There is or was a legend that a Huguenot couple lived, died and was buried on the site, and that their bodies were among those left behind, still buried somewhere beneath the cellar of the present house. Lovecraft took this idea and ran with it.

This seemed to be a bad luck house for the Harris family. Mr. Harris suffered some financial setbacks—he lost at least one ship, and even had an avaricious son-in-law embezzle money from his business.

Mrs. Harris had problems of her own. According to legend, she lost her mind after the untimely deaths of some of her children and was confined to an upstairs room. She was occasionally heard to shriek out the window of the room in French, a language she never spoke before moving into the house.

For a time, the house was apparently considered "unlucky," and was allowed to deteriorate. The present owners have restored it beautifully.

Lovecraft weaves some of the history and legend of the house in among more sinister creations and insinuations of his own. The mystery builds in layers until eventually, thousands of words later, we find ourselves in the basement of the Shunned House by flashlight, digging, looking for a still-active elder horror. Personally, I have always found the ending to be a letdown.

Henry L.P. Beckwith Jr. bluntly notes, "It is not haunted. There is nothing out of the ordinary—nor was there ever—buried under the basement."

On the wall of the building next to 135 Benefit, across the little park, you will see the outline of a building that is no longer there. In that building was once housed Dr. Bates's Electropathic Sanatorium. Dr. Bates was in business here from the 1880s into the 1930s, when he moved his practice to Jamestown. The doctor employed a wide range of medical practices, from the established and accepted (for the time) to the more experimental, such as electropathic treatments that, while not electroshock, did involve running electrical current through the body.

It has been pointed out that the dates of Lovecraft's "blank period" (1908–1912) fall into the time when Dr. Bates was in practice here. Perhaps, it has been speculated, the young Lovecraft was one of the patients here, and he first learned of the legends of the Shunned House during his visits.

There is another possible connection worth mentioning. Both L. Sprague de Camp in his *Lovecraft: A Biography* and S.T. Joshi in his *H.P. Lovecraft: A Life* have Lovecraft's aunt, Lillian Clark, living at 135 Benefit (Joshi gives 1919–1920 as the dates of her time living there as a companion to Mrs. Babbit, another resident). Perhaps she heard some stories and passed them on to her nephew.

Lovecraft makes passing mention of the Mercy Brown story, which is dealt with in detail further on.

It is to be noted that this is a private residence. Take a picture and enjoy the rest of your stroll on a crisp autumn day. Trespassers will be fed to the author's pet shoggoth, Dixie.

The current residents, while not being Lovecraft fans, are clearly in on the joke of living in his Shunned House. On the gatepost, you will see several small signs.

All the signs are in French.

THE BILTMORE

Built in 1922, the Biltmore is the grand dame of Providence hotels—a red brick skyscraper dominating the skyline for many years and *the* place to stay. A lavish ball attended by over one thousand guests marked the opening of the new hotel, which was nearly a small city of its own, with a florist, druggist and even a print shop on site. The rooftops had gardens and chicken coops to supply fresh produce and poultry to the kitchens. An attempt was made to keep ducks, but the ducks, perhaps realizing their ultimate fate, flew south one winter never to return.

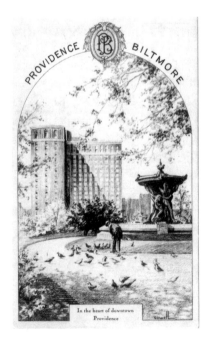

An early Biltmore advertisement. The view is taken from Burnside Park. *Courtesy of Louis McGowan.*

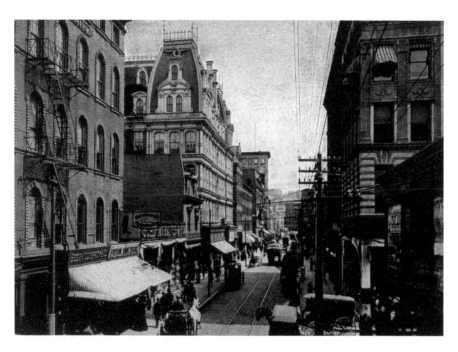

The bustling downtown was home to numerous grand hotels starting around the turn of the century. *Postcard courtesy of Louis McGowan.*

High times reigned at the Biltmore until October 29, 1929—Black Tuesday. Providence didn't fare any better than the rest of the nation during the stock market crash that precipitated the Depression.

One ruined stockbroker, who had been living it up the night before in high style, jumped out of his room's window on the fourteenth floor to his death that Tuesday morning when he heard the news. It is said that he haunts not only his room, but each room he passed on his final descent. Some guests have reported seeing something—or possibly someone—falling past their window. When they look out, there is nothing there.

THE BARKER PLAYHOUSE

Toward the south end of Benefit Street stands what was once St. Stephen's Church, built in 1840 for an Episcopalian congregation. It looks like anything but a church now, with its stucco façade and quietly secular appearance. The first congregation left after twenty years, and various other groups (usually Episcopalian) made use of the building until 1932, when a theater group, the Barker Players, took possession.

The Barker Players is the oldest little (amateur) theater group in the country and staged its first production in 1909 in the Talma Auditorium, which once stood on nearby South Main Street.

Like any good theater, it has the decency to be haunted. One would expect no less from a playhouse with an adjoining graveyard.

According to a few actors with whom I have spoken, the Barker is home to a playful, prankish ghost usually referred to as the "Ghost of Talma," or sometimes simply "Talma." One theory, based on the name of the resident spook, was that the ghost may have accompanied the players when they left the Talma Auditorium, settling at the old St. Stephen's Church a number of years later.

Talma likes to play little jokes—nothing dangerous or in any way harmful, but simple practical jokes.

One production of a murder mystery required the use of a prop dagger. The props master for the production was very organized, and laid out every prop on a large table backstage, arranging them in the order in which they were used and outlining each item in tape to mark its place. He could tell at a glance if everything was in order and ready to go, and he went over everything with a checklist before each show.

On opening night, taking his inventory, he found the dagger was missing. There was an empty space outlined in tape on the backstage table. No one

The Barker Playhouse is haunted by a ghost known as Talma. *Photo by Robert O'Brien.*

had it, no one had moved it and no one had seen it since the night before when it had been returned to its place after rehearsal.

Panic ensued backstage. The props master and his two assistants turned the place upside down while the audience took its seat out front. After some thirty frustrating minutes, a substitute weapon was found and used for that night, and the show went on.

After the curtain came down and the audience had gone home, the props master and his two assistants went over every inch of the Barker Playhouse, determined to find the missing dagger. He averred that they would not leave until they found it.

At about two o'clock in the morning, he called an end to the search, much to the relief of the two tired assistants. They had not found the errant prop, but had reached the end of their collective patience. The props master said he would simply go out and buy another fake dagger before the next show.

When the three of them turned around to head backstage, one of the assistants saw the dagger. It was onstage, lying in the doorway through which actors and actresses had made entrances and exits all night long.

It could not have been there before—if it had been, the dagger would have been seen by someone, kicked across the stage or tripped over.

It was only when they decided to call it a night that it reappeared—deposited, as so many claim, by the puckish Talma.

Earlier I mentioned the graveyard next to the Barker. With some three thousand graveyards scattered around the state, you would think that most buildings have one next door. Most of those interred here are from the Tillinghast family, a large and prominent family in early Rhode Island history. Pardon Tillinghast, interred here, was a Baptist minister, and he built the town's first wharf in 1680.

Despite the fact that there is only one marker, there are a number of bodies buried here. I was told that during one of the infamous hurricanes that flooded Providence, layers of earth were washed away exposing several of the old coffins. One ghoulish version of the tale has those coffins floating into the Barker's basement.

I spend a certain amount of time in cemeteries, looking for interesting epitaphs. In *The Devil's Dictionary*, Ambrose Bierce sardonically defines "epitaph" as "an inscription on a tomb, showing that virtues acquired by death have a retroactive effect."

One epitaph I have seen several times is simply, "Gone Home," which is rather touching. Another I've seen is "Gone, but know not where." On the grave of a doctor in Pawtucket you will find a large boulder that reads, "This is on me."

But without doubt, my absolute favorite comes from the stone of John Kerr, who was born in Scotland, died in Boston and was buried in Providence. It reads:

> *I dreamt that buried in my fellow clay*
> *close by a common beggar's side I lay.*
> *Such a mean companion hurt my pride,*
> *And like a corpse of consequence, I cried,*
> *"Scoundrel begone! And henceforth touch me not,*
> *More manners learn, and at a distance rot."*
> *"Scoundrel?" in still haughtier tones cried he.*
> *"Proud lump of earth, I scorn thy words—and thee.*
> *All here are equal, my place is now thine,*
> *That is thy rotting place, and this is mine!"*

TALES OF WITCHCRAFT

It seems that when people think of New England folklore, tales of witchcraft dominate their minds. Undoubtedly, the infamous Salem witch trials are to blame. I am often asked about witches in Rhode Island, and tales of witchcraft are few and far between here. But there are a few stories featuring witches, fortunetellers and prognosticators.

A German fortuneteller began placing ads for his services in Rhode Island newspapers as early as 1760. Fifty years later, a freed slave named Sylvia Tory told fortunes for a quarter from her small shack in South County. Something of a local character, Sylvia reportedly died at the age of 104. Shaking her head sternly, she told one client that he had "no fortune to tell," and warned him never to travel east—to do so would be his doom. But he did travel east some time later (to New Bedford, some 30 miles east of Sylvia's shack), and was dead within 2 weeks.

From her parlor on Westminster Street, Mrs. M.L. Bremer, an "English Astrologer and Clairvoyant," gave psychic guidance to businessmen and predicted the outcomes of battles against the Kaiser's troops in the trenches of France—or so said her publicity.

There are a few stories of a character known as Granny Mott, who was said to be a witch. The most often told tale concerns a farmer who was driving cattle along a country road when his way was blocked by a large black cat. Neither the cattle nor the cat would move. The farmer had his gun, but no ammunition, so he loaded the barrel with a silver button from his coat and fired at the frustrating feline. The wounded cat crawled away into the brush and the farmer and his little herd continued on their way.

The next day, Granny Mott was reported to be badly hurt, and when the doctor examined her, he found a deep wound in which was embedded a silver button.

Busy Westminster Street where Mrs. Bremer told fortunes for curious clients. *Postcard image courtesy of Louis McGowan.*

Variations of this story may be heard throughout New England, leading to the conclusion that it stems from an old English folktale.

There are some stories of Tall Katern, a survivor of the *Palatine*, who had the reputation of being something of a witch. We shall meet her presently in the *Palatine* chapter.

So there are very few tales of witches to be found in Rhode Island, but we more than make up for that deficiency with numerous vampires.

STORIES FROM BEYOND PROVIDENCE

"Searchers after horror haunt strange, far places."
—H.P. Lovecraft.

MERCY BROWN

Exeter is a small, rural village in the western part of the state, and this unassuming little place is home to what is undoubtedly the most infamous story in Rhode Island.

The *Providence Journal* covered it when it happened; Bram Stoker knew about it; H.P. Lovecraft refers to it in "The Shunned House" and borrowed some of the ideas. It brings hundreds of visitors every year to a little out-of-the-way graveyard, many probably hoping to encounter something.

In Exeter lived a family named Brown, and in the 1890s there were several untimely deaths in the family over a fairly short period. George Brown's wife Mary died in December 1883; Mary Olive, the eldest daughter, likewise perished six months later. After a respite of seven years, son Edwin began to exhibit symptoms of the same affliction that had killed the others, and he was sent west to Colorado Springs for his health. In his absence, his sister Mercy Lena became ill and died on January 18, 1892, at the young age of nineteen.

Today, we recognize that the cause of these unfortunate deaths was tuberculosis, or as it was called then, consumption (no doubt because the afflicted seemed to be consumed by the disease). This is a highly infectious disease caused by a bacillus and spread by coughing or sneezing. It flourishes in crowded and unsanitary conditions (spreading rapidly among the urban poor, for instance). The infected grow thin and pale, coughing up blood and suffering a general weakness as they are "consumed." The disease slowly destroys the lungs, but can affect other parts of the body as well, including the brain. It was often referred to as "the White Plague" in nineteenth-century America, causing many deaths throughout the century, including that of Poe's twenty-four-year-old wife, Virginia.

As in any B horror movie, the villagers grew nervous and rumors were flung about carelessly. While the bacillus causing tuberculosis had been

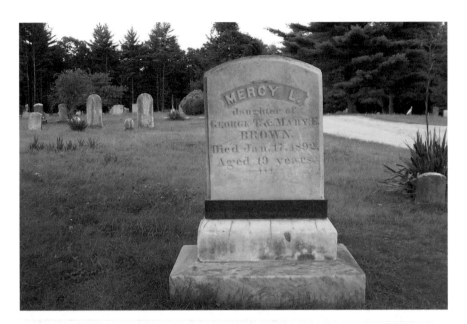

The grave of Mercy L. Brown, the nineteen-year-old tuberculosis victim who became known as Rhode Island's most famous vampire. *Photograph by Robert O'Brien.*

discovered by Dr. Robert Koch in March 1882, the news had not reached rural Exeter. People there had their own explanation, and it was nothing so mundane as a lowly bacterium.

According to the locals, there was a vampire preying on the Brown family.

It should be made clear that they did not think of vampires in quite the way we do—no one was envisioning an elegant Béla Lugosi–style character crawling up out of the grave and biting his victims on the neck. It was more nebulous than that. It was believed that there was some sort of vampiric contagion emanating from (or possibly residing in!) the body of one of the deceased family members, and that it must be tracked to its source and dispatched.

According to the *Providence Journal*, George Brown was "besieged on all sides by a number of people" for weeks and turned a deaf ear for as long as he could, but finally gave in on March 17, 1892.

On that day, in the company of Dr. Metcalfe, the doctor who had attended the family members during their illnesses, George went out to the graveyard where his wife and two daughters were buried.

They were looking for signs of a vampire.

The headline of the March 19, 1892 *Providence Journal* article read:

EXHUMED THE BODIES
Testing a Horrible Superstition
In the Town of Exeter.
BODIES OF DEAD RELATIVES
TAKEN FROM THEIR GRAVES

George and Dr. Metcalfe exhumed the bodies of the mother and daughter. Mary Brown was mummified. Olive was only a skeleton "with a thick growth of hair."

Mercy Brown, nine weeks dead, had been placed in a simple crypt until she could be properly buried in the spring when the ground thawed. Her corpse was closely examined by Dr. Metcalfe. A second *Providence Journal* article published on March 21 relates:

> *The heart and liver were removed and in cutting open the heart, clotted and decomposed blood was found, which was what might be expected at that stage of decomposition. The liver showed no blood, though it was in a well-preserved state. These two organs were removed, and a fire being kindled in the cemetery, they were reduced to ashes and the attendants seemed satisfied....And the belief is that, so long as the heart contains blood, so long will any of the immediate family who are suffering from consumption, continue to grow worse; but if the heart is burned, that the patient will get better. And to make the cure certain, the ashes of the heart and liver should be eaten by the person afflicted. In this case the doctor does not know if the latter remedy was resorted to or not, and he only knows from hearsay how ill the son Edwin is, never having been called to attend him.*

There are three elements traditionally included in the story that, perhaps interestingly, are not reported in the newspaper articles.

One is that the body of Mercy Brown had moved or shifted in her coffin.

Second, that the ailing Edwin was brought over to the fire to inhale the fumes of his sister's burning heart.

The third is that the ashes of Mercy's heart were mixed with water or medicine and given to Edwin to drink, "to make the cure certain," as outlined above. While the practice is shudderingly mentioned several times in the article, there is no statement that Edwin actually did so.

Indeed, a letter to the editor of another newspaper, the *Pawtuxet Valley Gleaner*, dated March 25, 1892, provides a third contemporary account, reporting (among other things) that the "deponent saith not how the ashes were disposed of."

It is almost disappointing to hear that these ghoulish particulars, almost always included in every telling of the tale, do not appear in the original accounts.

Whether or not he ingested the ashes of his sister's heart, Edwin died of tuberculosis less than two months later, on May 2. He was, however, the last member of the Brown family to die of the disease.

Michael Bell, author of *Food for the Dead*, a very thorough examination of the Mercy Brown case and several other cases of alleged vampirism in New England, has pointed out that vampirism is a folk medicine explanation. It explains what is happening, why it is happening and provides a cure. Folklore always has an answer. Readers are referred to his excellent book for more information.

Bram Stoker, author of *Dracula* (published in 1897), was aware of the story, as several newspaper clippings about the case were found among his papers after his death. Some have attempted to draw parallels between Mercy Brown and the novel's Lucy Westenra.

There are various reports of strange things happening in the graveyard, a veritable laundry list of "usual" alleged paranormal manifestations—orbs, lights, strange sounds.

The grave is a popular site for "legend trippers," of course. My friend Christopher and I visited the grave one October day some years ago. We found flowers and a small pumpkin, into which someone had carved the words, "To Mercy—You Go Girl!"

In August 1996 Mercy's gravestone was stolen by a person or persons unknown. There were tire tracks in the graveyard. The theft was as puzzling as it was pointless. Thankfully, the stone was returned a few days later. It is now held in place with an iron collar.

I enjoy telling the Mercy Brown story at Hallowe'en, and I tell it with all the creepy embellishments about shifting corpses and ashy potions. But it should be remembered that Mercy Brown is not, and never was, a vampire. She was a normal young woman, who died horribly and whose body was later desecrated to satisfy a bizarre and unsavory superstition. I am left to wonder what she might have been like as a person. We know that she quilted, as a quilt made by her has survived, but that is seemingly all we know. I wonder what she might think of her weird fame among those who tell ghost stories.

Mercy Brown is often referred to as "the Last Vampire," as hers was the last of a string of exhumations in Rhode Island. The state was occasionally referred to as "the Transylvania of America," and those who did so may only have been half joking.

"Not a Rhode Island Tradition, But Settled Here" was a subtitle on the second *Providence Journal* article. It went on to relate:

How the tradition got to Rhode Island and planted itself firmly here cannot be said. It was in existence in Connecticut and Maine 50 and 100 years ago, and the people of South County (RI) say they got it from their ancestors, as far back in some cases as the beginning of the eighteenth century.

A little further on, the article says:

The old superstition of the natives of Exeter, and also believed in other farming communities, is either a vestige of the Black Art, or, as people living here say, is a tradition of the Indians.

While it is perhaps not surprising that a journalist, writing for the modern, urban reader of the day, might repeat the idea that this is an "Indian" tradition, it does not actually seem to be.

There are at least four other "vampire exhumations" in Rhode Island, beginning with Abigail Staples in 1796, and continuing with Sarah Tillinghast in 1799, Nancy Young in 1827 and Juliet Rose in 1874. All of these cases follow the same general pattern as the Mercy Brown story, so much so that some of the details from one story become confused with hers. For instance, it is usually said that Mercy's heart was burned on a nearby rock, but the original articles make no mention of a rock. That detail comes from an 1888 account of the Sarah Tillinghast case, as recounted by Sidney Rider. Somehow, that piece of information was absorbed into the Mercy Brown legend.

These other stories have been forgotten, and are really only remembered by specialists in this rather esoteric area of local history. But many Rhode Islanders know the Mercy Brown story—she is not just "the Last Vampire," she is *the* vampire for so many, almost a distillation of all the various vampire legends from around the state.

Why—because hers was the most recent story? Or is it something else?

Mercy Brown may have also inspired another vampire legend.

Some distance away from the small cemetery where Mercy rests is the grave of another supposed vampire girl, Nellie Vaughn.

The story as I first heard it was that a local high school teacher was relating the story of the state's best-known vampire to the students one Hallowe'en, but couldn't remember her name or exactly where she was buried. When the students went looking for the gravesite, they drove right past Mercy Brown's grave and ended up in another cemetery, where they discovered the headstone of Nellie Vaughn, who died at roughly the same

age and date (give or take a few years). Strangest of all, Nellie's epitaph read: "I am waiting and watching for you."

The kids concluded that they had found their vampire. Strange goings-on have been reported ever since, including strange whispers being heard, the allegation that no grass will grow on her grave and even supposed sightings of Nellie herself. But none of these stories go back more than a few decades, before the teacher's students got lost looking for Mercy Brown.

No one has ever been able to find the teacher, establish where or what the teacher taught or even whether the teacher was male of female. None of the legend-tripping students have ever been identified.

It seems that what we have here is a story about a story.

THE HAUNTING OF RAMTAIL MILL

For the first century or so of its history, Rhode Island looked to the sea, with Newport being one of the major seaports in the young nation. As the days of the China Trade came to a close, the state's focus shifted to industry.

Samuel Slater built the first successful American mill in 1793, powered by the flow of the Blackstone River. Trained in England, Slater brought his mechanical expertise to Pawtucket and soon had dozens of Arkwright machines clattering away, spinning thread. This one man started the Industrial Revolution in America and changed the face of the landscape, with hundreds of mills soon springing up along rivers throughout the state. Small villages grew up around the mills, sometimes housing entire families who worked in the local mill from sunrise to sunset, six days a week; fathers and mothers working alongside children as young as ten.

One such cotton mill was Ramtail Mill in the rural town of Foster. Ramtail was owned by two brothers named Potter. Bales of mixed cotton were brought to the mill and fed into the carding machines, where the cotton was combed and combed by rows of sharp wire teeth. After carding, the cotton was ready for drawing, roving and winding and then was finally spun into thread. The whole works were driven by the water wheel on the Ponagansett River that ran past the mill.

The Potters hired a man named Peleg Walker as night watchman (some sources say that he was a son-in-law). Walker was a disagreeable man, and the solitary life of the night watchman seemed to suit him perfectly. After the last worker had left for the evening, he locked the doors and spent the night making his rounds through the building with its suddenly eerily silent machinery, the sounds of the river flowing and the voices of relaxing workers drifting in through the windows. As the moon rose in the sky, many saw him through the windows of the mill, his lantern illuminating his sharp face.

All that remains of the once-thriving Ramtail Mill are a few foundations and a small graveyard. *Photograph by Christopher Martin.*

In the morning, usually around six, Walker would ring the bell to summon the workers, and when the last ones arrived he would leave to sleep away the day in his modest shack.

According to the legend, the brothers and their watchman argued furiously and constantly, although the cause of their disagreements was lost long ago. The most common supposition is that the quarrel was over money. The son-in-law theory may help explain why the Potters did not simply fire him.

After several years of shouting and fighting, Peleg Walker spoke the last words the brothers ever heard from him: "One day, you will have to take the key to this mill from a dead man's pocket."

This dark prophecy came true a few weeks later. One May morning in 1822, the bell did not ring and a few workers, rising late, made their way down to the mill to find the door locked. The Potter brothers were sent for and they forced the door open to find Peleg Walker swinging from the bell rope. His sharp face was dark with blood. Tucked into one coat pocket was the key, fulfilling his final sinister promise.

Walker was laid to rest three days later in the little graveyard not far from the mill. The Potters didn't hire a new watchman, and just tried to put the whole episode behind them.

The grave of Peleg Walker, former night watchman who allegedly haunts the area of Rhode Island's only "official" haunting. *Photograph by Christopher Martin.*

Peleg Walker apparently had other ideas.

One night a few weeks later, workers were awakened around midnight by the pealing of the bell being rung with the manic energy of a soul in distress. The brothers and a handful of others raced down to the mill, but as they drew near the bell fell silent. Entering the building, they found it empty.

When this happened again a couple of nights later, they took down the bell rope.

And when the bell continued its midnight ringing, they took it down, too.

This bought them a few weeks' rest. But then one night, several workers noticed that the mill's wheel was turning backward—against the flow of the Ponagansett. The Potters ordered the headrace gate to be closed, damming the flow, and all involved tried to go back to bed.

Shortly afterwards, all were awakened by the sound of the mill machinery running at top speed in the middle of the night. It took almost an hour to get the equipment locked down again.

When several said they had seen Peleg's lantern passing from window to window in the darkened mill, workers started to seek employment elsewhere.

About a year after his death, Peleg himself was seen by three men. He was walking from the mill to one of the outbuildings, swinging his lantern by his side. They said it was unmistakably Peleg Walker—they'd recognize his stooped shoulders and heavy gait anywhere.

Eventually, as more and more workers left, keeping the mill operational was a losing battle, and the brothers closed it down. It stood empty and silent, and if Peleg Walker still made his nightly rounds, no one was there to notice. The little mill village quite literally became a ghost town, with some of the braver children in the area playing among the abandoned houses, much to the dismay of cautious mothers.

Someone burned the mill in 1873, and the woods moved in to cover over the remains. You can still find the ruins of the old mill and houses if you look hard enough.

But something else remains—another item worth mentioning. The 1885 census of Rhode Island, compiled under the direction of Superintendent Amos Perry, contains the usual information about Foster, listing its villages, its brooks, its rivers, its hills and its mills. On page thirty-six of the census you will find Ramtail Factory listed, along with the simple comment, "haunted," making it, to the best of my knowledge, the only officially recognized haunting in the state of Rhode Island.

The Newport Tower

At the western end of Newport's Touro Park stands a twenty-four-foot-tall controversy in stone. At least, according to some. To many others, there is no controversy at all.

The object under discussion goes by various names—the Old Stone Mill, the Newport Tower, the Newport Mystery Tower, the Viking Tower, the Norse Tower—and the list goes on and on.

The tower is a cylindrical edifice, some twenty-four feet high and twenty-two feet in diameter, standing upon eight pillars forming archways. There is no longer a roof, so the structure is open to the sky. There are a few holes along the inner walls that probably once supported beams, and also a lone window and small fireplace. Who built the tower, when and why, form the basis for the controversy.

The first reliable reference to the tower is found in the 1677 will of Governor Benedict Arnold (great-grandfather of the infamous traitor. Interestingly, members of the same family, also bearing the name, can be found buried in the same graveyard as Mercy Brown). Arnold twice refers to "my stone built wind mill."

For many years, most people simply thought of the tower as an old colonial windmill, if they thought about it at all. A little eccentric, perhaps, but nothing mysterious.

There was no debate over the tower's origins until 1837, when Danish author Carl Christian Rafn published *Antiquiates Americanae*, in which he argued that the tower had in fact been constructed by Viking explorers around AD 1000 as a church. He was very certain of his conclusion, despite never having even visited the tower in person.

Setting the precedent for those who would later follow, Rafn based his conclusions on faulty information, shaky reasoning and a desire to reach

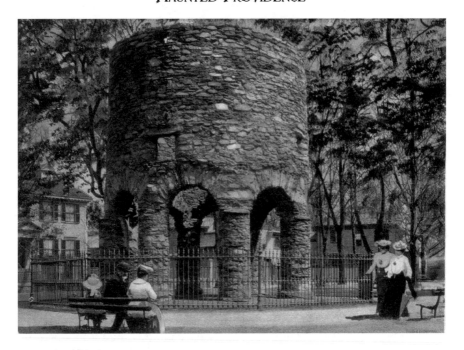

A vintage postcard of the Newport Tower, Newport's oldest mystery. *Courtesy of Christopher Martin.*

a predetermined conclusion. Deciding that the structure must be a Norse church, he set out to prove it.

This theory took hold in the popular imagination, and to this day, Newport has various businesses incorporating the word Viking—the Hotel Viking, Viking Tours and so on. One wag has even pointed out that Newport's 845 telephone exchange spells out *VIK*.

Latching onto the new explanation, Henry Wadsworth Longfellow penned "The Skeleton in Armor" in 1841, saying that the poem "is connected with the old Round Tower at Newport." It describes a Viking warrior sailing to the New World with his bride, to escape her disapproving father. Two stanzas make mention of the tower:

> *Three weeks we westward bore,*
> *And when the storm was o'er,*
> *Cloud-like we saw the shore*
> *Stretching to leeward;*
> *There for my lady's bower*
> *Built I the lofty tower,*
> *Which, to this very hour,*
> *Stands looking seaward.*

There lived we many years;
Time dried the maiden's tears;
She had forgot her fears,
She was a mother;
Death closed her mild blue eyes,
Under that tower she lies.
Ne'er shall the sun arise
On such another!

While there is ample evidence that the Vikings reached eastern Canada, establishing an unsuccessful colony at L'Anse aux Meadows, nothing suggests they ever ventured so far south as Rhode Island.

One writer of Portuguese descent has spent considerable time attempting to prove that the tower was built by Portuguese sailors, probably from the lost Corte Real expedition of 1502. The arguments offered are, to say the least, unconvincing, relying heavily upon numerous unproven and unsupported claims.

Some years ago, searching through my favorite secondhand bookstore in Providence, I came across a copy of Kathleen O'Loughlin's slim booklet titled simply *Newport Tower*, which argues that it was built by a Welsh prince in the 1100s. I noticed with some amusement that the publication date was April 1, 1948.

That day in the bookstore, I formulated Raven's Rule of the Newport Tower. Simply put, everyone cheers for the home team.

Scandinavian writers think it is obviously Viking.

Portuguese writers feel it is clearly Portuguese.

Irish writers think it is indisputably Celtic, positing a Welshman if no Irish candidate can be found.

(And every good rule deserves an exception: one writer with the very Caucasian name of Gavin Menzies propounds the theory that the tower was built by the Chinese during some medieval trips to the United States.)

None of these alternative theories have much in the way of solid evidence to support them. Most rest on supposition, conjecture and reasoning backwards from an ethnocentric conclusion. And none are taken seriously by mainstream historians or archaeologists.

Radiocarbon dating done in the 1990s gave the tower's dates as 1440–1710. No Vikings, no Welsh princes and only an outside chance of Portuguese or Chinese sailors.

Archaeological digs done around the tower in an effort to uncover its origins have consistently failed to find any artifacts predating the colonial period. Not a thing.

If the tower was built before the 1600s, anyone should be forced to ask: "Where is the pre-colonial stuff?"

Where are the Welsh artifacts, the Portuguese objects, the Viking materials, the Chinese relics? A Welshman never left something behind by accident? A Portuguese sailor never forgot something? A Viking never dropped something? A Chinese mason never misplaced something?

Reading through various alternative theories on the Newport Tower's origins, I am reminded of the so-called authorship controversy surrounding William Shakespeare's plays. A number of scholars through the years have spent considerable time and effort arguing that someone other than Shakespeare authored the plays and poems. Candidates include Francis Bacon, Christopher Marlowe, even Queen Elizabeth. The scenarios and evidence offered are at least as flimsy and bizarre as those offered up by opponents of the colonial windmill explanation of the tower.

I have done some reading about each of these debates. On the surface, both are intriguing. But after a few pages, I am scratching my head, wondering, "Who really believes this stuff?"

THE STRANGE DEATH OF
REBECCA CORNELL

J ust outside of Newport is the town of Portsmouth, established in 1638 by Anne Hutchinson and her followers. Hutchinson was a devout and outspoken woman who shared many of Roger Williams's beliefs regarding religious freedom, and like Williams before her, she stood trial for her views and was sentenced to banishment from the Massachusetts Bay Colony. Arriving in what is now Portsmouth, she began the first settlement in the New World to be founded by a woman. In 1643, she and several of her daughters were killed during a Native American attack in New York. Her daughter Susannah alone was spared. It is said that the attacking Native Americans had never seen a child with red hair.

Anne's bad end was seen by many as God's harsh judgment upon "an American Jezebel, who had gone a-whoring from God" (according to John Winthrop, Governor of the Massachusetts Bay colony).

In February 1673 Rebecca Cornell was an elderly widow who lived on a hundred-acre farm in Portsmouth. Living with her in the house was her also-widowed son, Thomas, and his family, consisting of Thomas's second wife, Sarah, and two of the children, along with two hired men.

It was not a happy home. Thomas and his mother argued constantly, save on those occasions when they were not speaking to one another at all. There is also some evidence of friction between Sarah and Rebecca (what wife wouldn't chafe at living in her mother-in-law's home?). Thomas was in debt to his mother, having not paid the rent he owed her for several months in a row, and this only caused further strife.

According to statements made by friends and neighbors, Rebecca seemed quite depressed and had hinted that she might move in with another of her sons in the spring, but had added that she might be "done away with" before she could. At least once, surprisingly, she confessed to thoughts of

suicide, which would have been a mortal sin according to her seemingly strict religious beliefs.

It was not a healthy home life at all.

On February 8, 1673, Thomas spent some two hours talking with his mother in her upstairs room. We do not know what they discussed. He made his way downstairs to join the rest of the household for a supper of salted mackerel. Rebecca remained upstairs that night, saying that salt mackerel did not agree with her.

After supper, Thomas sent one of his sons, Edward, upstairs to see if Rebecca wanted some boiled milk. When the boy opened the door to his grandmother's room, he found a fire burning out of control, and ran back downstairs to alert the others.

Five people rushed to the second floor—Henry Straite, one of the hired men, a servant named James Mollis, followed by Thomas, son Edward and wife Sarah. Straite entered the room ahead of the others, and was the first to discover the burning body lying at the foot of the bed. He said, "Here is a drunken Indian burned to death"—a very strange thing to say under the circumstances.

Thomas Cornell, entering just behind Straite, cried out, "Oh Lord, it is my mother!"

Straite was wrong. Cornell was right.

Rebecca's body was, according to Mollis, "lying on the floore, with fire about Her, from her Lower parts to neare to the armepits." He identified her only "by her shoes."

A brief inquest was held, and members of the household were questioned, resulting in the conclusion that the aged widow "was brought to her untimely death by an Unhappie Accident of fire as Shee sat in her Rome."

After her burial a few days later, Rebecca's brother, John Briggs, came forward with an unusual story: he had been visited by her ghost in the night.

As he was falling asleep, she appeared to him and said, "See how I was burnt?"

This bizarre episode, along with the rumors that were spreading, was enough to necessitate a second inquest. Rebecca's body was exhumed and her remains subjected to a second autopsy, which revealed a suspicious wound just above her stomach. She had apparently been stabbed and burned.

During that second inquest, several who were questioned offered additional and more detailed information than they had the first time they were questioned.

Thomas supposed that his mother had fallen asleep while smoking her pipe, and that "a coale" fell from her pipe, setting off the blaze that

killed her. Bur her pipe was nowhere to be found in the room. And if his explanation was correct, why hadn't she put out the fire herself, or at least called out for help?

According to Sarah, when Edward opened the door to Rebecca's room, a "great Dogge" ran out and leaped over him. There is no other mention anywhere else of the family owning a dog, let alone one large enough to jump over a standing boy. The dog is never again mentioned. Great spectral dogs appear in English folklore as harbingers of death, or sometimes as minions of the devil. According to some of the unfortunates tried for witchcraft in Salem twenty years later, Satan sometimes appeared to them in the form of a black dog with fiery eyes. Was this mysterious dog in the Cornell house real, or a later invention created to suggest that something literally diabolical was afoot?

Several others testified to the growing animosity between mother and son, citing examples of Thomas's failings as a son and callousness toward his mother.

Unsurprisingly, Thomas was arrested for the murder of his mother.

During the trial, which lasted only one day, a Mrs. Almy offered testimony that Sarah and their friend Mrs. Shaw had visited Thomas in jail, where he was confined under armed guard. Mrs. Almy testified that Mrs. Shaw had overheard the husband and wife conversing in whispers, saying, "If you will keepe my Counsell, I will keepe yours."

Leaving aside for the moment that this is clearly hearsay, it should be pointed out that in the seventeenth century, one meaning of "counsell" was clearly "advice," but it could also be taken to mean "secret."

John Briggs repeated his story of the victim's postmortem visit. One author observed, "Strange as it seems…this bit of flimsy testimony had the most to do with the indictment and sentencing of Thomas Cornell."

Was there a conspiracy to do away with Rebecca Cornell? What are we to make of the mysterious leaping, vanishing dog? Why did no one investigate John Briggs?

Thomas Cornell was found guilty and hanged on May 23, 1673, maintaining his innocence to the end. He could have petitioned the General Assembly for clemency, but did not. Instead, friends and supporters submitted a petition on his behalf, requesting that he be buried next to his mother on the family farm instead of next to or even beneath the gallows, as was customary at the time. The petition was denied, but the assembly did allow him to be buried on the family land as long as the site was near the road, and nowhere near his mother. They also allowed a headstone to be placed, marking the grave.

Even someone with no legal background must wonder how anyone could be convicted on hearsay, supposition and innuendo. Ghosts? Mysterious dogs? Whispers of "Counsell"? It is certainly one of the strangest cases on record.

Sarah Cornell, who had been pregnant during the ordeal, gave birth to her third daughter shortly after the execution. Perhaps in protest, she named the child Innocent.

THE *PALATINE* LIGHT

There is a tangled thicket of conflicting stories surrounding Block Island's ghost ship, the *Palatine*. History tells one story, oral tradition tells another and versions told on the island differ significantly from those told on the mainland. Much of the story was lost for over a century, only resurfacing in the early twentieth century after some diligent research.

Tiny Block Island is some nine or ten miles off the coast of Rhode Island, and was charted by Dutch sailor Adriaen Block in 1614. For many years it was isolated and truly insular, inhabited by only a few. Tradition maintains that it was a hideout or temporary haven for a variety of pirates, miscreants and even Revolutionary War deserters. It is an island of many stories and many ghosts.

But undoubtedly its most famous story is the *Palatine*, and the *Palatine* Light.

To begin with, the ship in question was not even called the *Palatine*, but the *Princess Augusta*. She sailed from Germany in 1738, carrying some 340 passengers from the Rhine Palatinate, who would have been known as Palatines. This must have led to the later confusion. It is easy to imagine the ship being referred to as "the Palatine ship" because of her passengers. Similarly, today people take "the Block Island Ferry," even though there are three different vessels, none of them with that name. After many, many years of telling the story, the name *Princess Augusta* was lost, and she came to be known as the *Palatine*.

After making a brief stop in England (she was an English ship, with an English crew), she set sail for Philadelphia. Apparently, she had made a similar voyage two years earlier under a different captain.

According to the later deposition of her officers, the *Princess Augusta* encountered "small wind and thick weather" during a rough crossing. She was blown off course in a storm, and the captain ordered that the

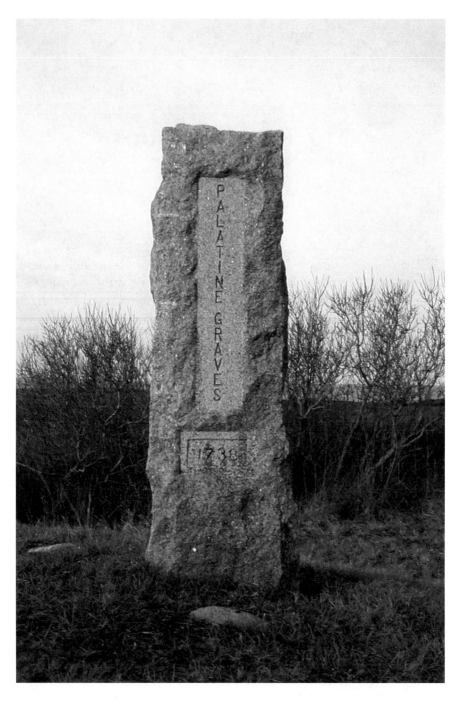

A monument on Block Island marking the graves of the *Palatine* passengers. *Photo by Christopher Martin.*

mizzenmast be cut down when the ship showed signs of strain during the tempest.

Tradition relates that the onboard water supply, kept in large casks, was contaminated, leading to illness and death among the passengers. About half of the passengers died during the voyage and many of their bodies were dumped overboard.

Worse, the captain died and the first mate took command. The story usually depicts the first mate, Andrew Brook, as a heartless and cruel man who starved his passengers despite having a plentiful supply of hardtack aboard. As there is no information detailing how the captain died, some have speculated that Brook murdered him to seize command of the ship. This is only speculation, but the kind of speculation that makes for a good ghost story.

Eventually, on December 27, 1738, the *Princess Augusta* found herself just off the coast of Block Island. There are at least two different versions of what happened at this point in the story.

One version, told on the mainland, relates that the island was home to the notorious "wreckers," who lured ships to their doom by setting out false beacons, sending ships to run aground in the shallows. The ships would then be ransacked by the wreckers.

Native Block Islanders deny that their ancestors had a hand in anything so nefarious.

Either way, the *Princess Augusta* ran aground on the Hummocks, a group of rocks and sandbars off the northern spit of the island. Freezing and starving passengers hurriedly disembarked, many probably grateful to make any kind of landfall after such a bad voyage.

Once again, there are several versions of what happened next, but most versions seem to agree that the surviving passengers removed their goods from the ship (over the protests of the greedy Brook or the wreckers, depending on who you ask), and the damaged ship was carried away with the rising tide, only to run aground again a couple of days later. Once again floating away, she broke up and was lost beneath the waves.

The Palatines were taken in for a time by Simon Ray, chief constable of the island. The Palatines whose bodies were brought ashore or who died shortly after arrival were buried on what was once his land. In the 1940s, a monument was raised to mark their resting place.

Some of the survivors stayed on the island—one of them was known as Tall Kattern, who according to later tradition was a fortune teller and witch.

At some point in the many retellings of the tale, a major element was added—that the ship did not break up and sink but instead was burned, either by accident or by the angry islanders.

Other parts of the story were altered to fall in line with this new addition. Suddenly, Tall Kattern, trapped aboard the burning vessel, cried out that she would marry any man who rescued her. She was saved by a slave named Newport and, good to her word, married him.

Another woman, Mary van der Line, was also trapped, but no one came to her aid. Her screams echoed across the waters as she went down with the fiery ship (although the version I heard as a boy, related by a cab driver on the island, had Tall Kattern as the doomed woman).

According to this new twist on the old tale, the burning ship, now known as the *Palatine*, would appear on the horizon every year between Christmas and New Year's, lighting up the sky with fire. Some, listening closely, could hear the tortured shrieks of Mary van der Line. It was said that the phantom ship would appear every year until the last of the wreckers and their accomplices died. The *Palatine* Light was reportedly seen for a number of years, even by some alive today.

In 1867, John Greenleaf Whittier composed a poem describing the legend, declaring it "a fitter tale to scream than sing." In it, he perpetuates the story of the merciless wreckers, fixing this version of the story in the public's mind for decades.

> *Down swooped the Wreckers, like birds of prey,*
> *Tearing the heart of the ship away,*
> *And the dead had never a word to say.*
>
> *And then, with ghastly shimmer and shine*
> *Over the rocks and the seething brine,*
> *They burned the wreck of the* Palatine.
>
> *In their cruel hearts, as they homeward sped,*
> *"The sea and the rocks are dumb," they said:*
> *"There'll be no reckoning with the dead."*
>
> *But the year went round, and when once more*
> *Along their foam-white curves of shore*
> *The heard the line-storm rave and roar,*
>
> *Behold! Again, with shimmer and shine*
> *Over the rocks and the seething brine*
> *The flaming wreck of the* Palatine!*"*

Most people, if they know the story at all, know a version similar to what Whittier laid out.

There have been some attempts to explain away the *Palatine* Light by supposing that it is the result of some vaguely-described gasses escaping from the sea bottom, or even schools of phosphorescent fish.

But such explanations are far less appealing than a phantom ship, whatever version of the legend you might prefer.

EPILOGUE

Telling ghost stories is common to many cultures, if not every culture, across the globe. It is a deeply human activity. Ghost stories may serve to connect people to their locale, or to one another. Or they may just be fun. As someone who believes that ghosts come from within and not without, I find it unsurprising that so many ghost stories bear more than a passing resemblance to one another or to stories from other places. Often when I am traveling and asking new friends about their local ghost tales, I'll hear a story that reminds me of one from back home in Providence.

Stories are fluid and ever changing, and the endless variations are proof that the stories are alive. I have recorded a number of stories as I have heard them, and embellished them here and there with my own touches. I don't doubt that some will know different versions of the stories related here, and that's simply the nature of the beast—or of the ghost, in this case.

I hope you have enjoyed this little stroll through my home.

And if you feel a tap on your shoulder and there's no one there, don't worry—it's just me.

About the Author

Rory Raven is a mentalist who performs at colleges, clubs, corporations and private events throughout the United States. He offers fantastic mind reading shows and lectures on esoteric subjects. When not on the road, he conducts the Providence Ghost Walk, a walking tour through the haunted history of Providence, where he makes his home with his wife and various animals. For more information, visit www.roryraven.com.

Visit us at
www.historypress.net